Casual Coloring 5

David Wilkins

©2016 David Wilkins

First Publishing 2016

ISBN- 13: 978-1535543200

ISBN- 10: 1535543205

With Causal Coloring 5 the designs are becoming more complex. To me this is the same as with life, the older I become it seems as if life becomes more complex. The Plus to all of this is you have more options to use your growing ability to take control of the page and assert your choices to the designs provided *(I came out of the therapist office hyped today).*

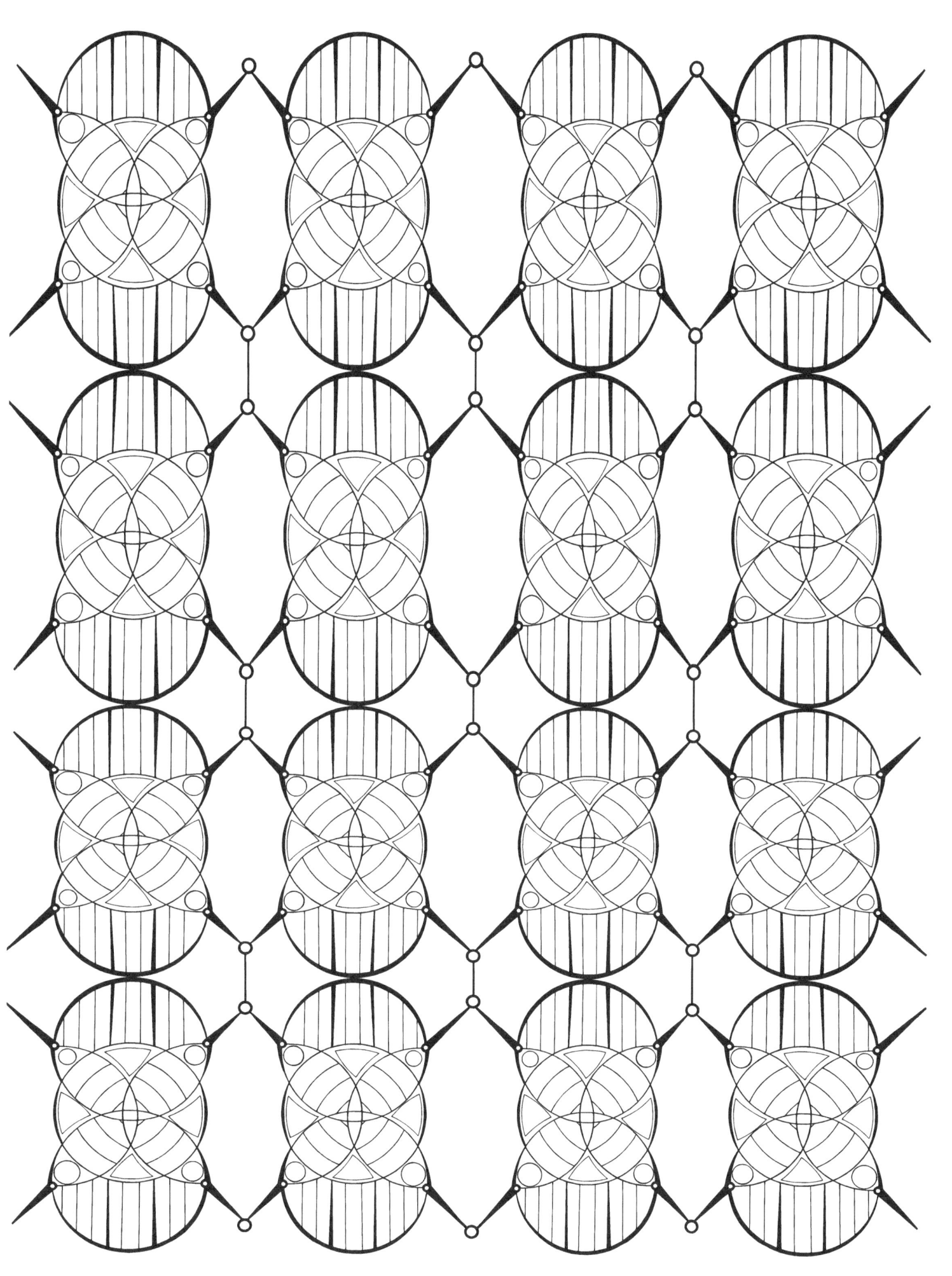

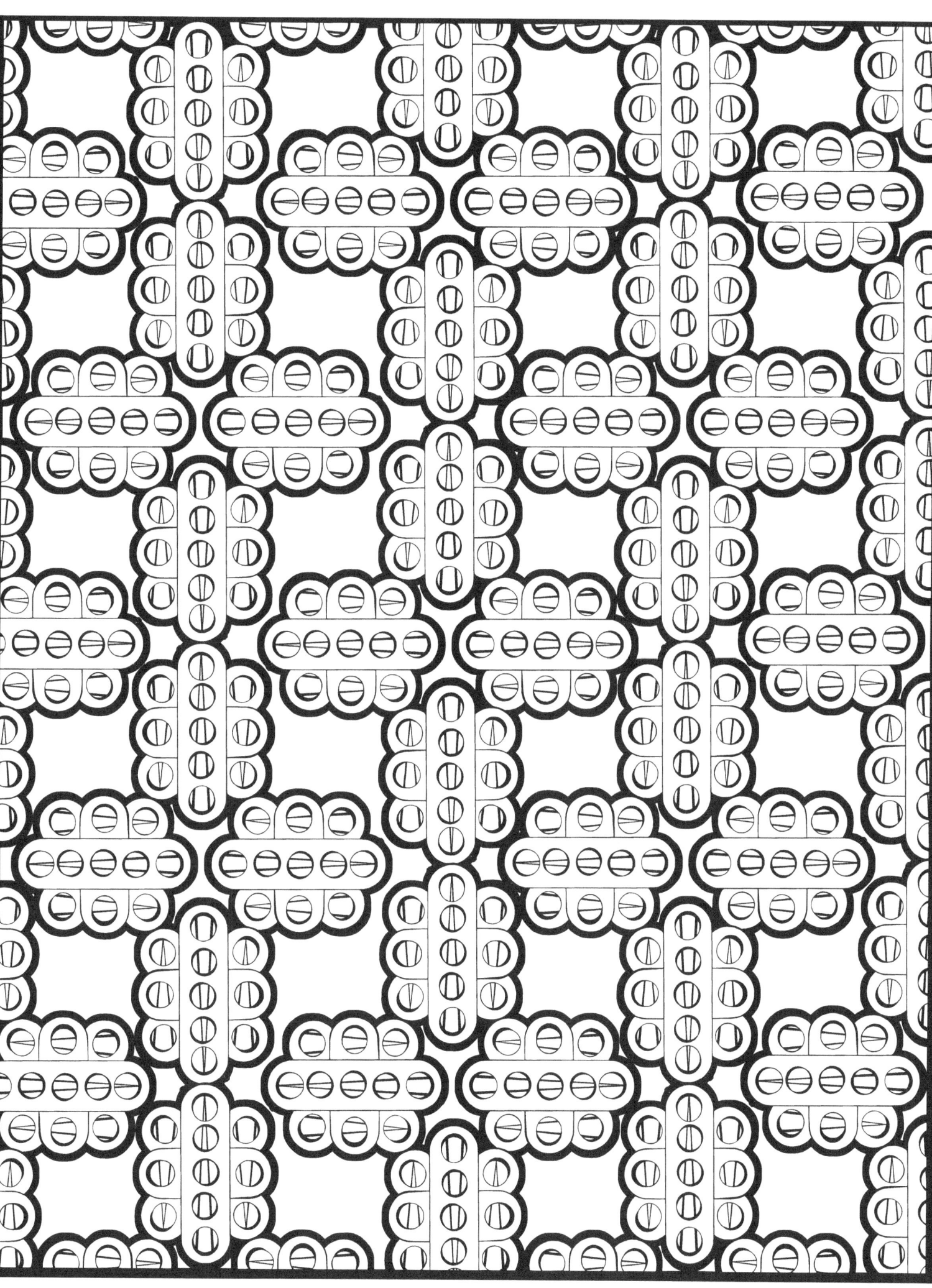

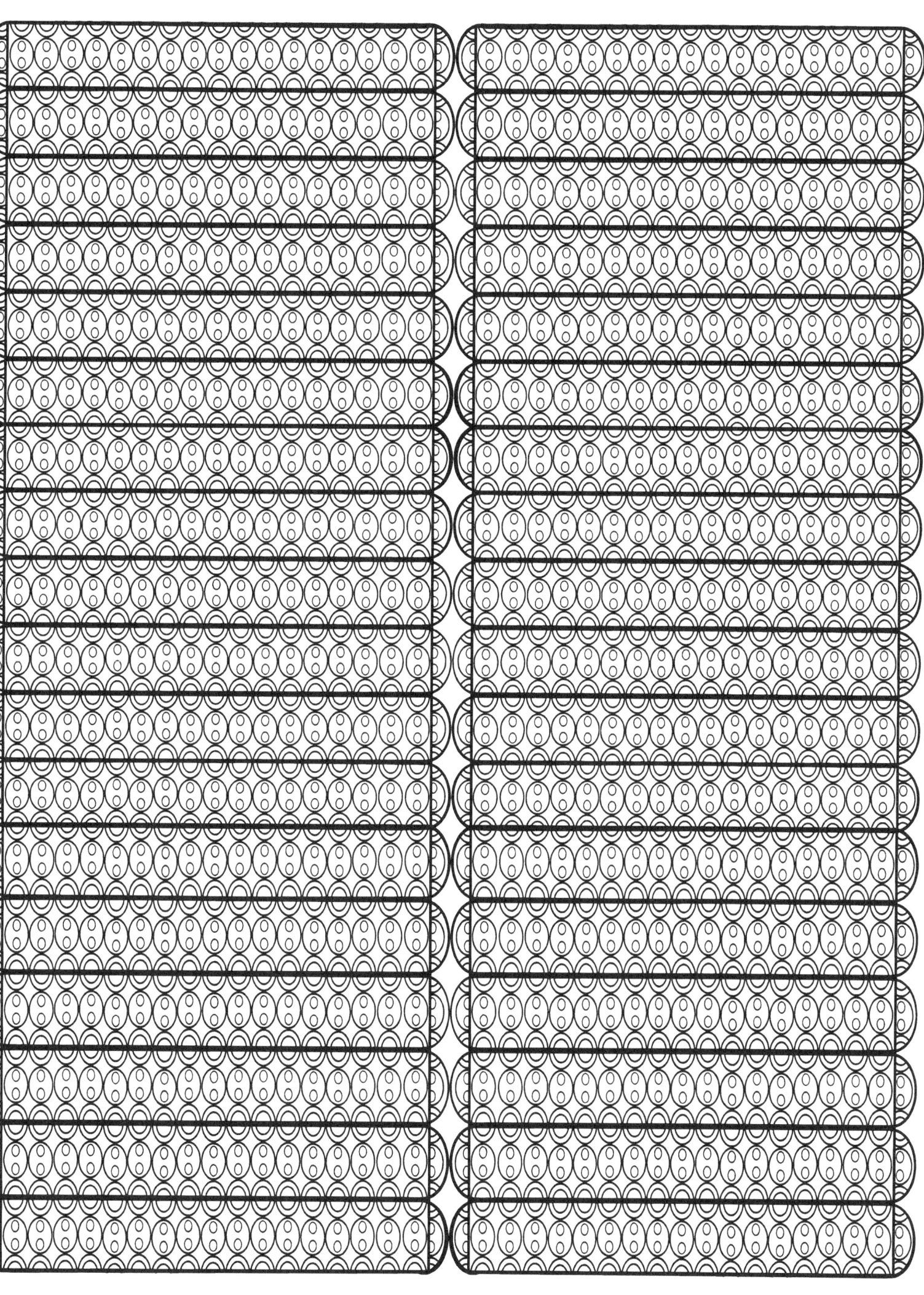

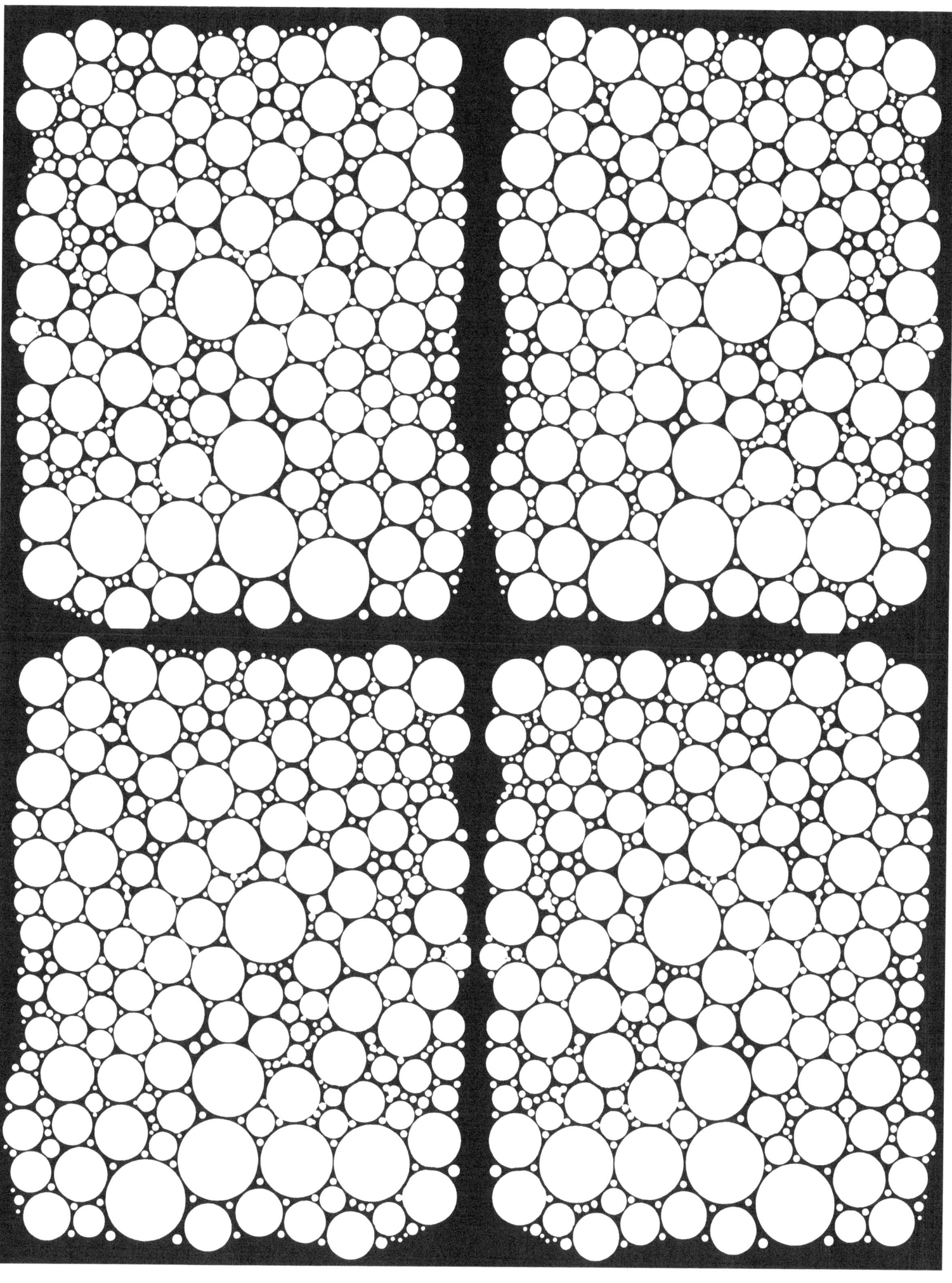

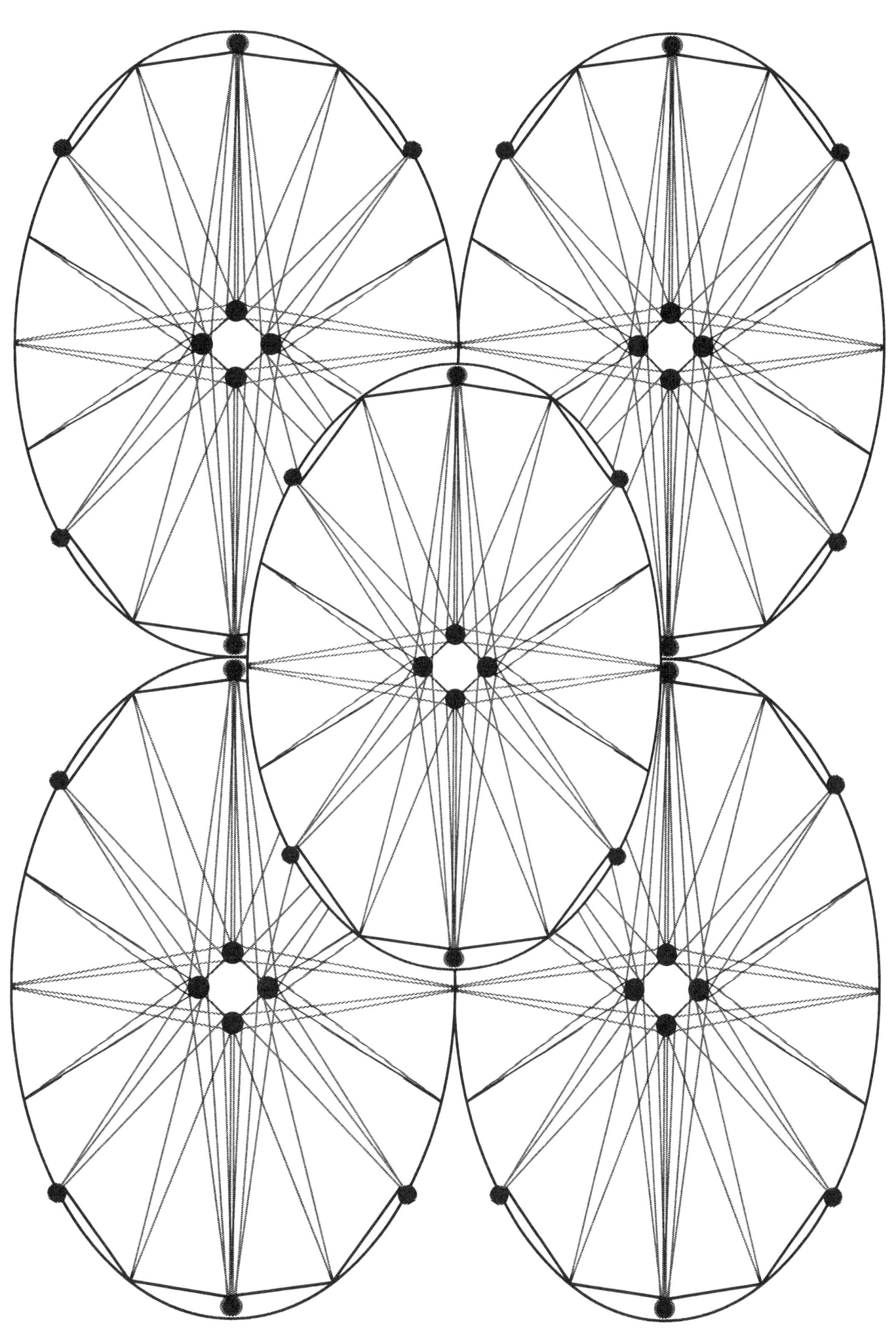

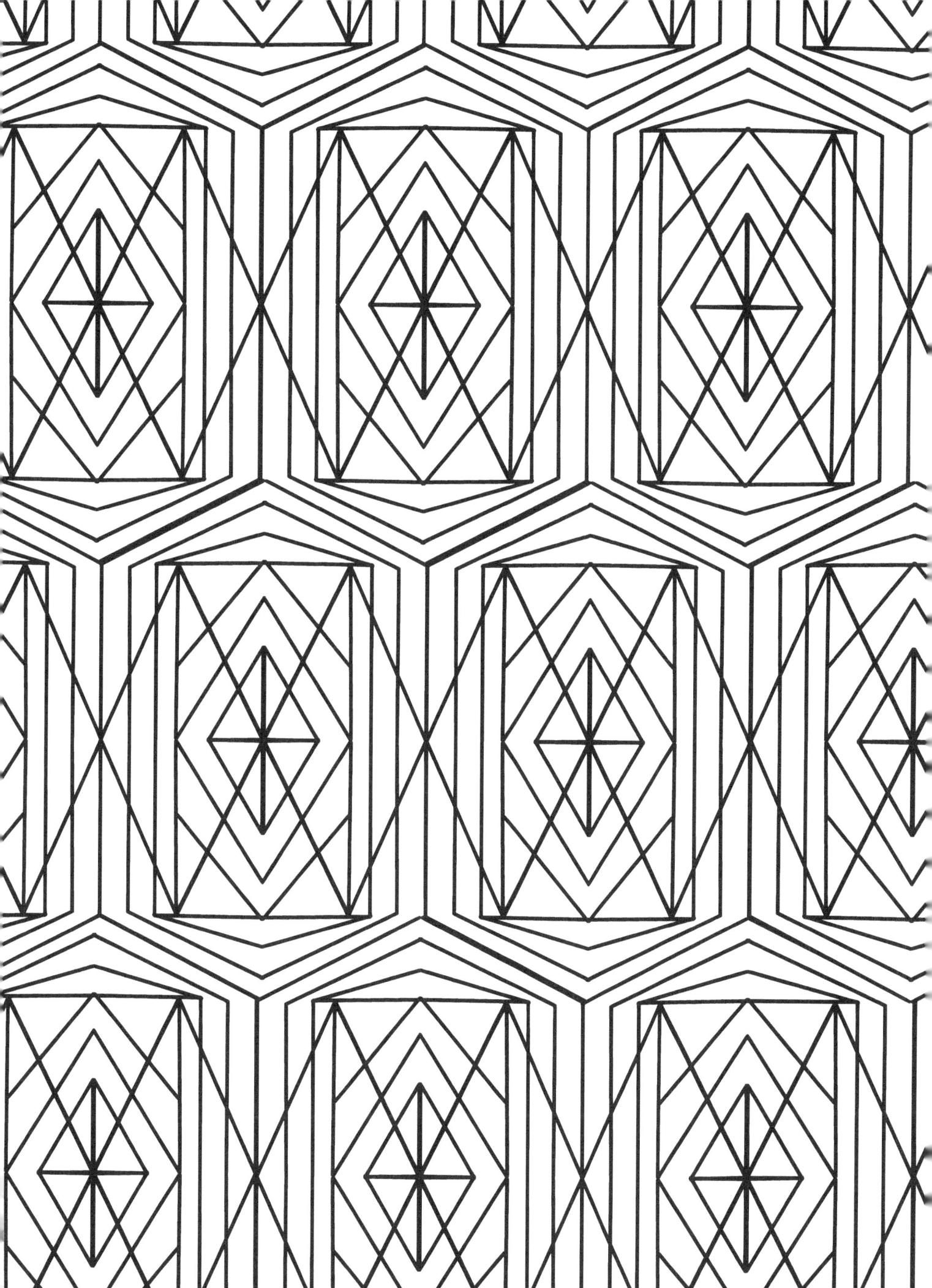

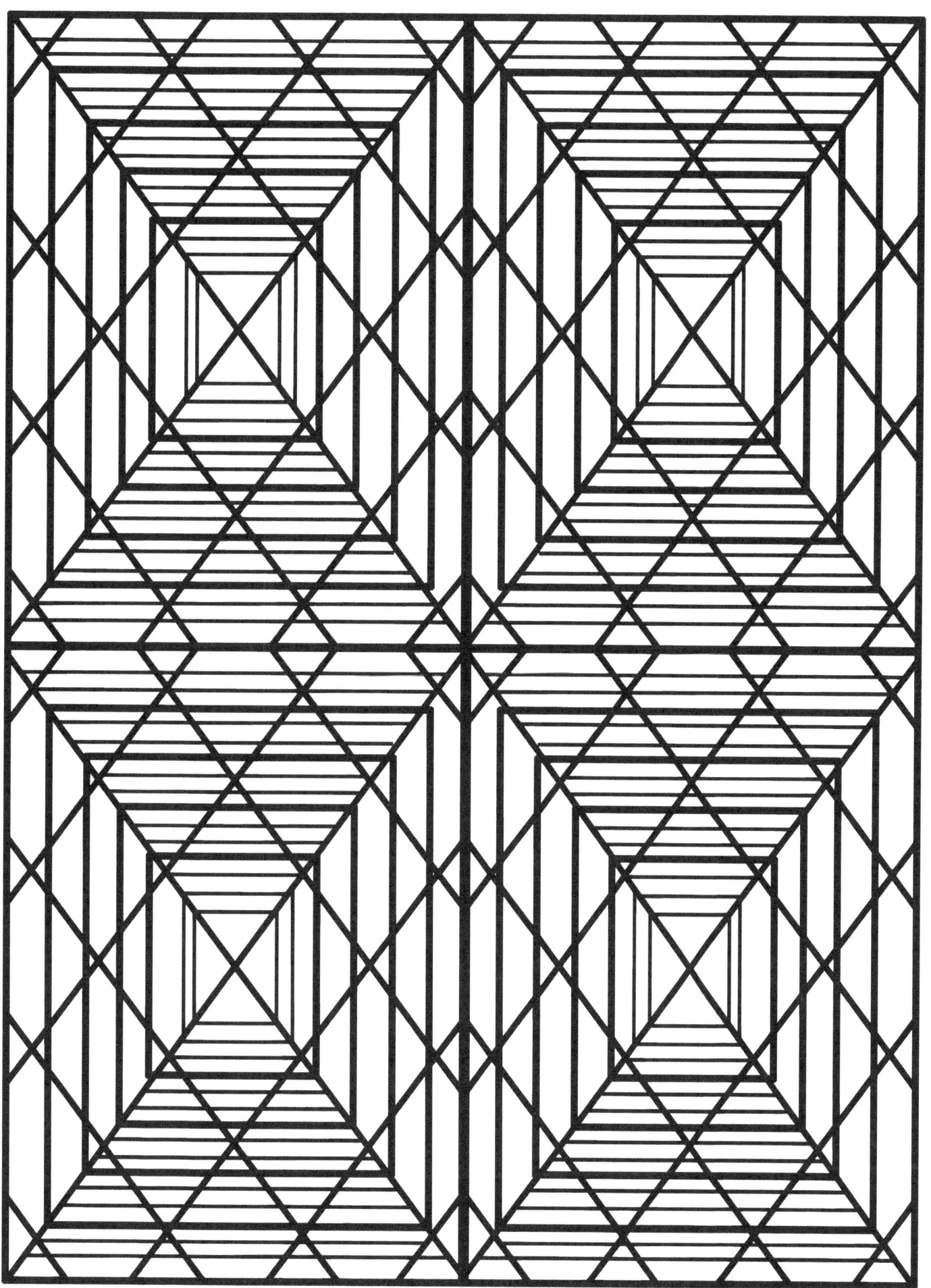

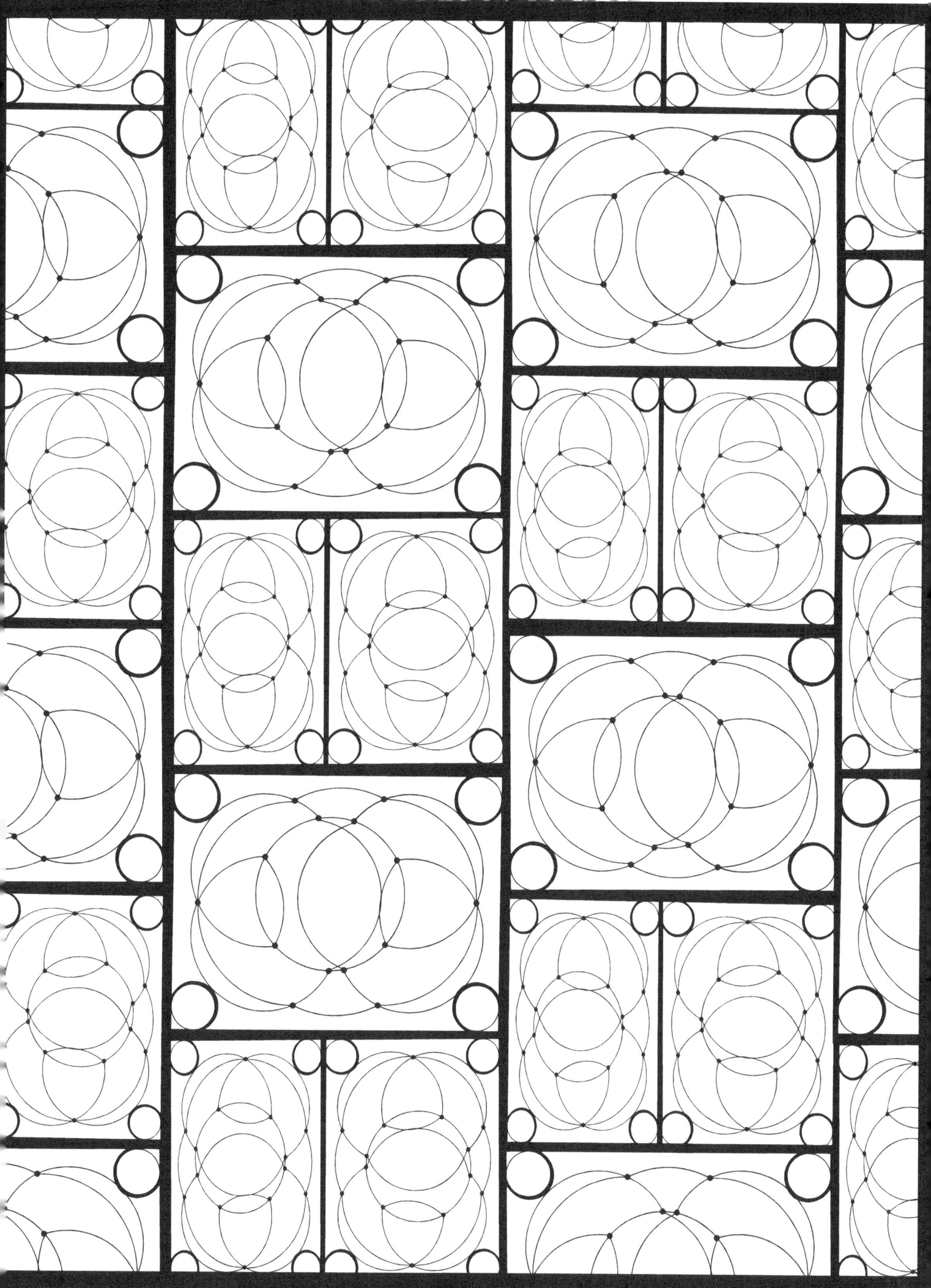

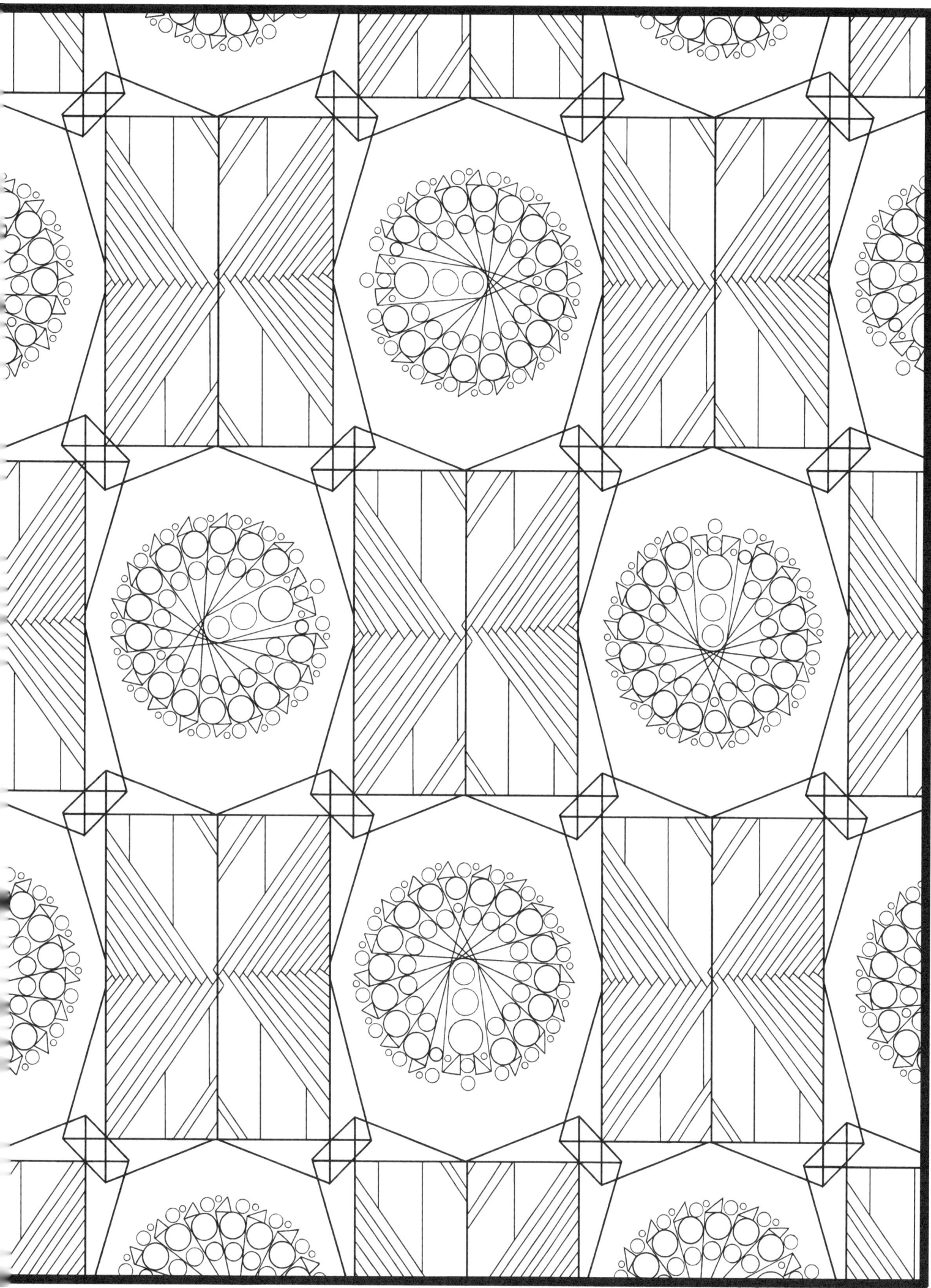

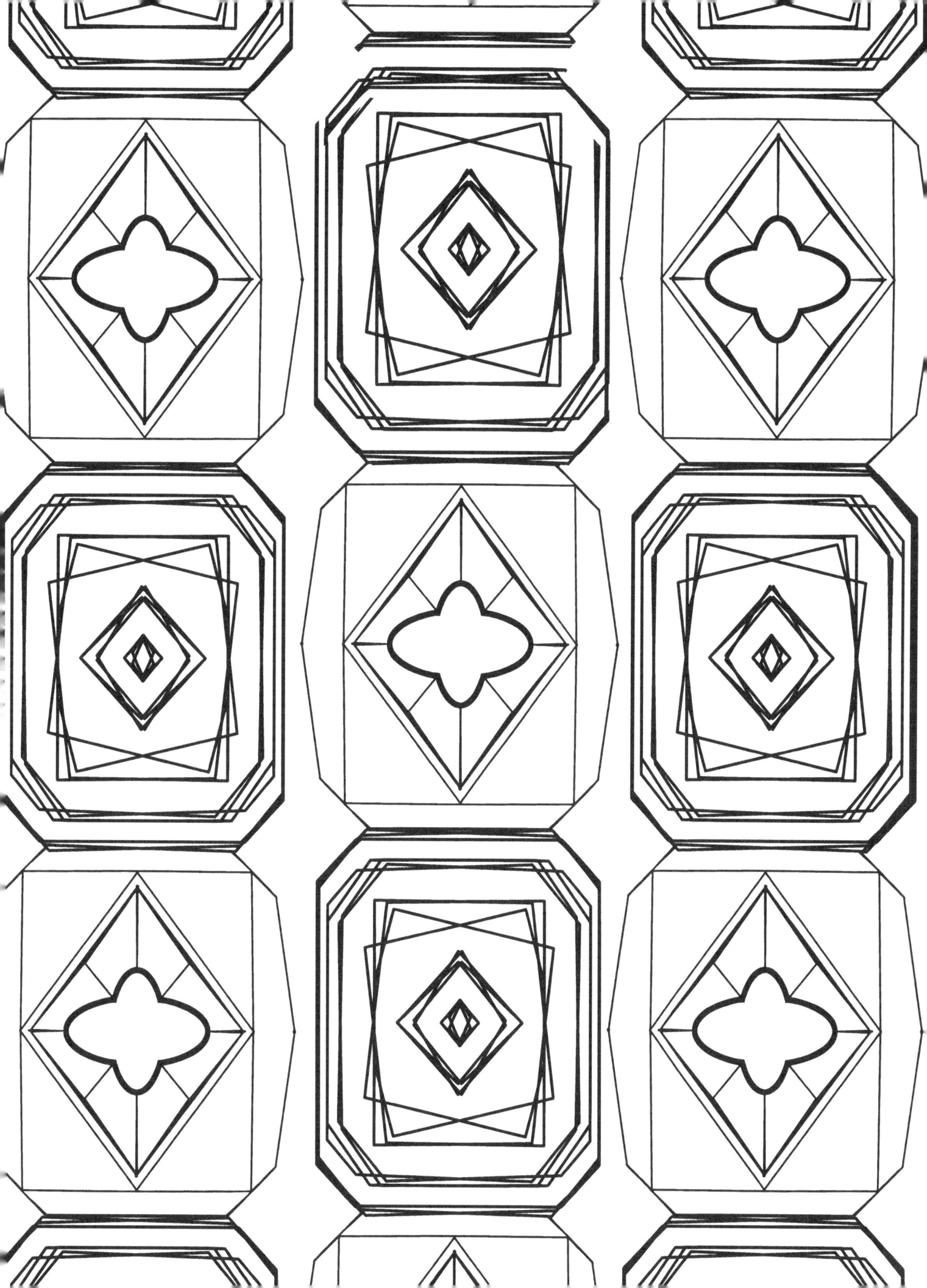

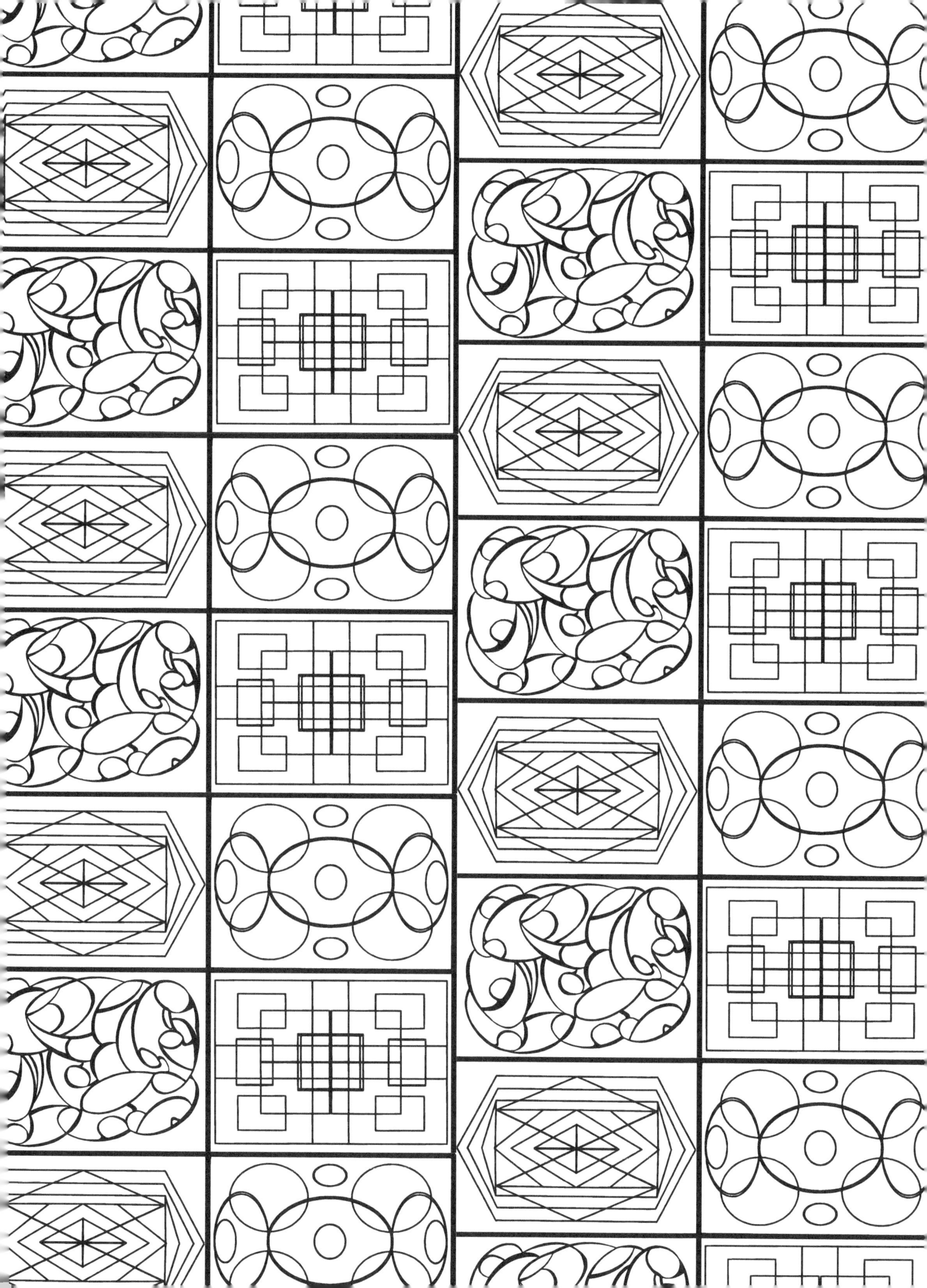

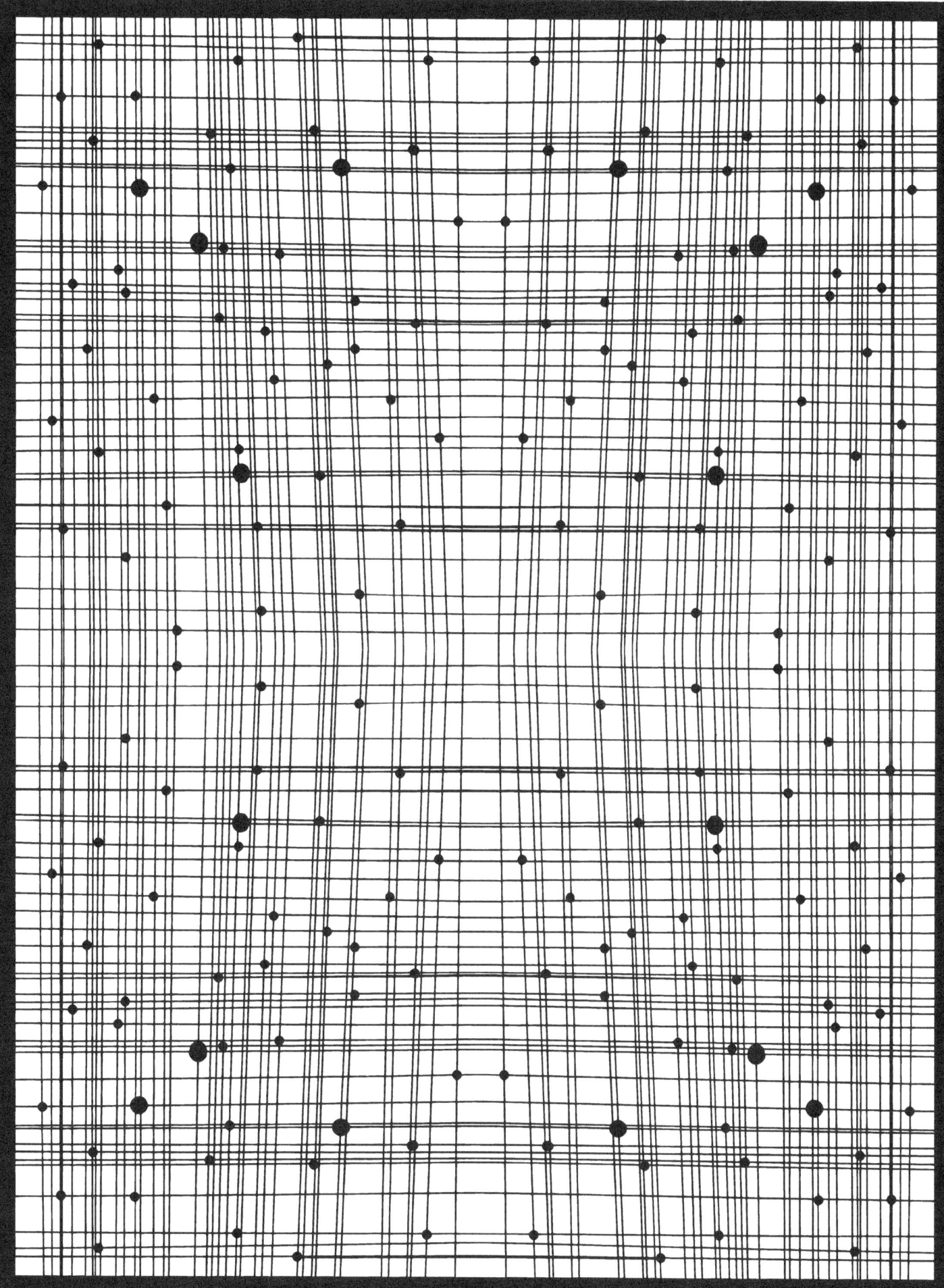

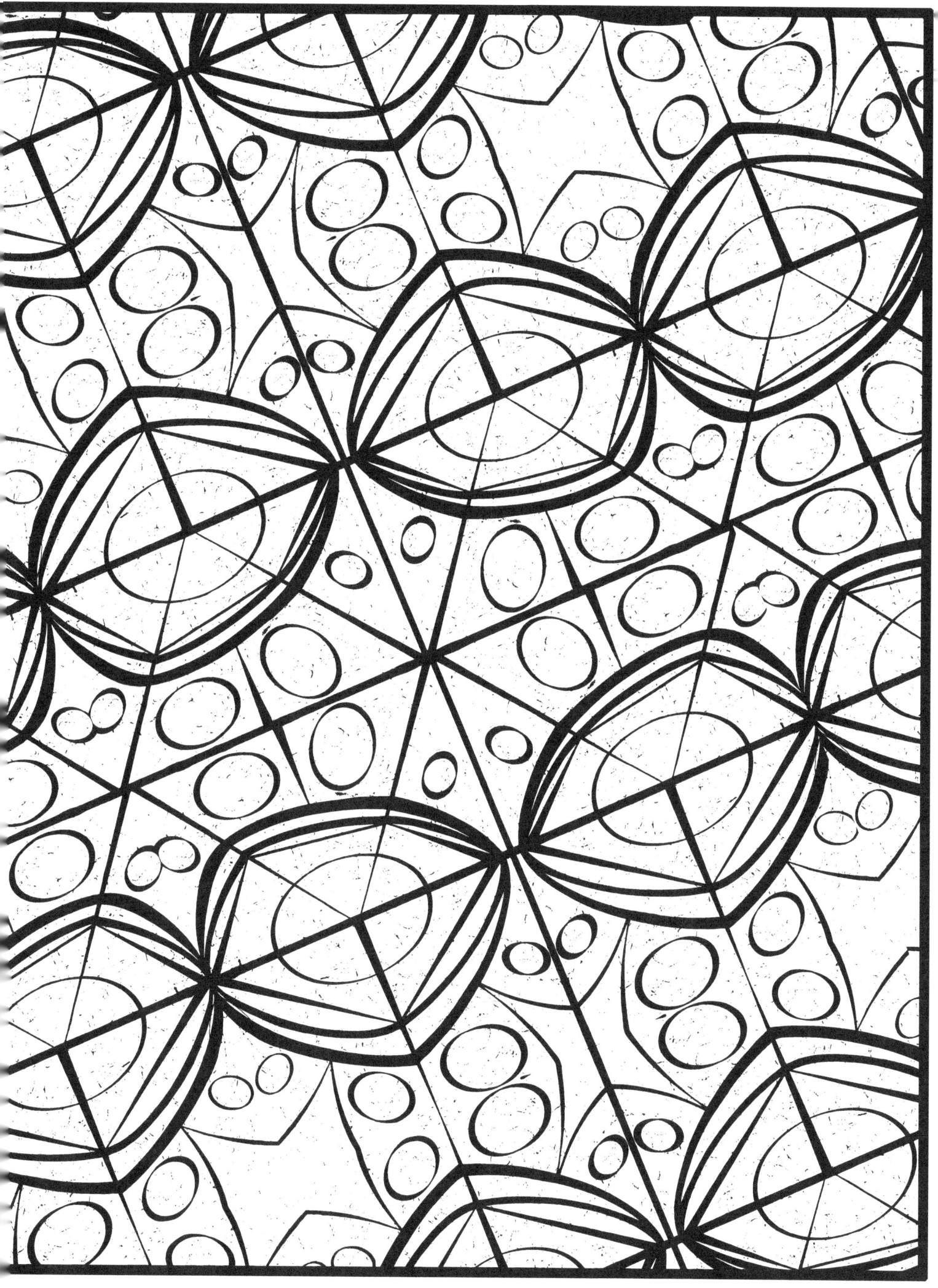

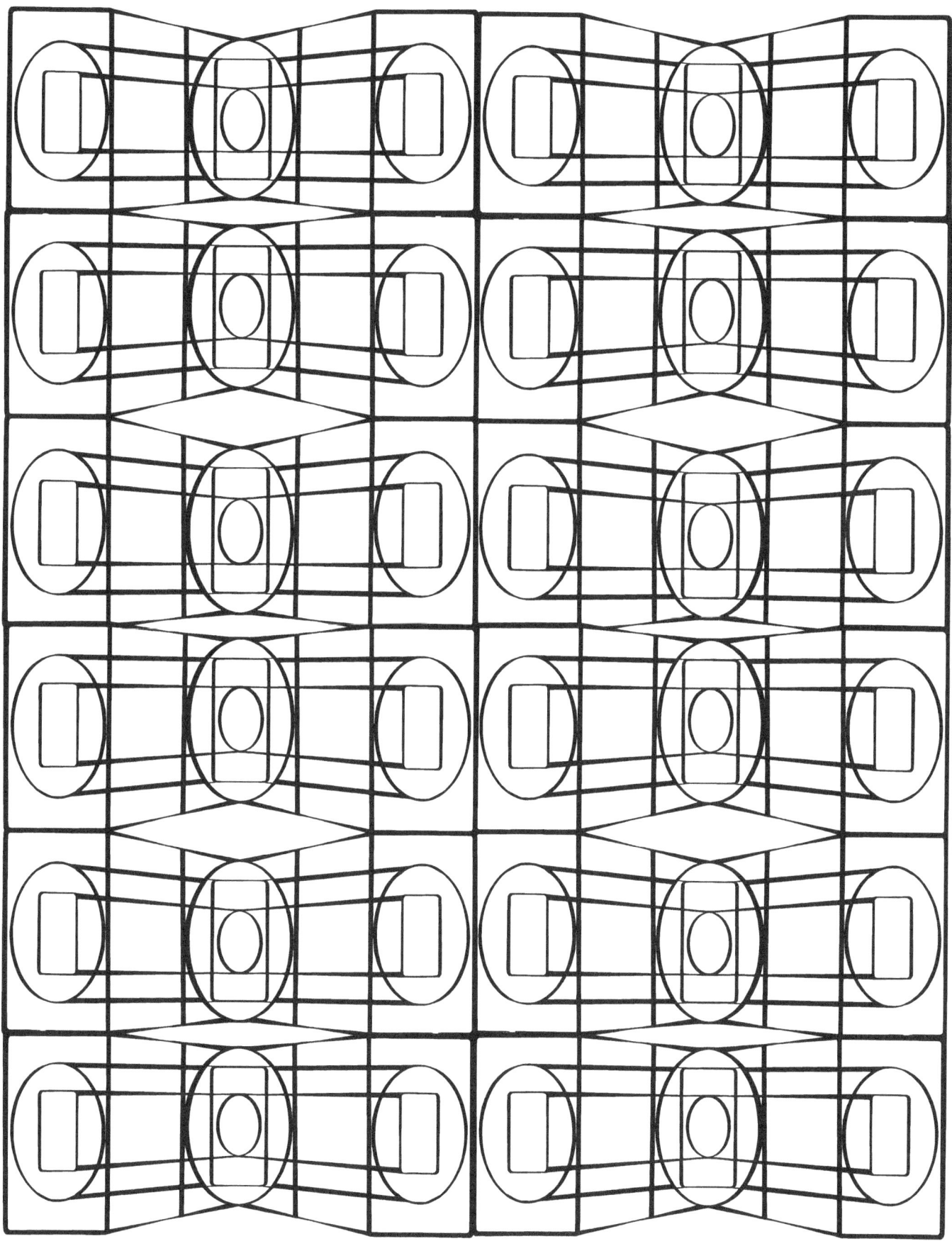

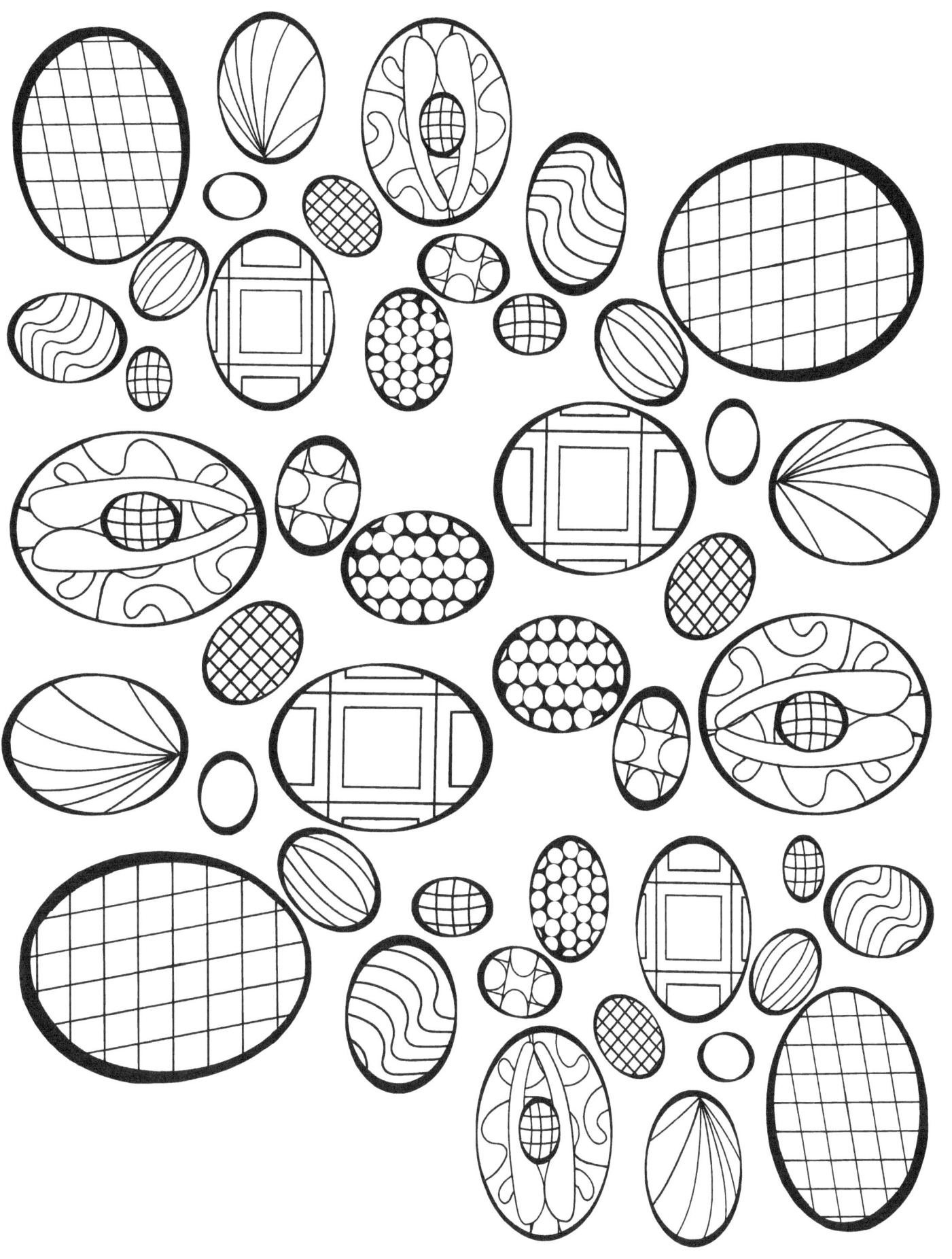

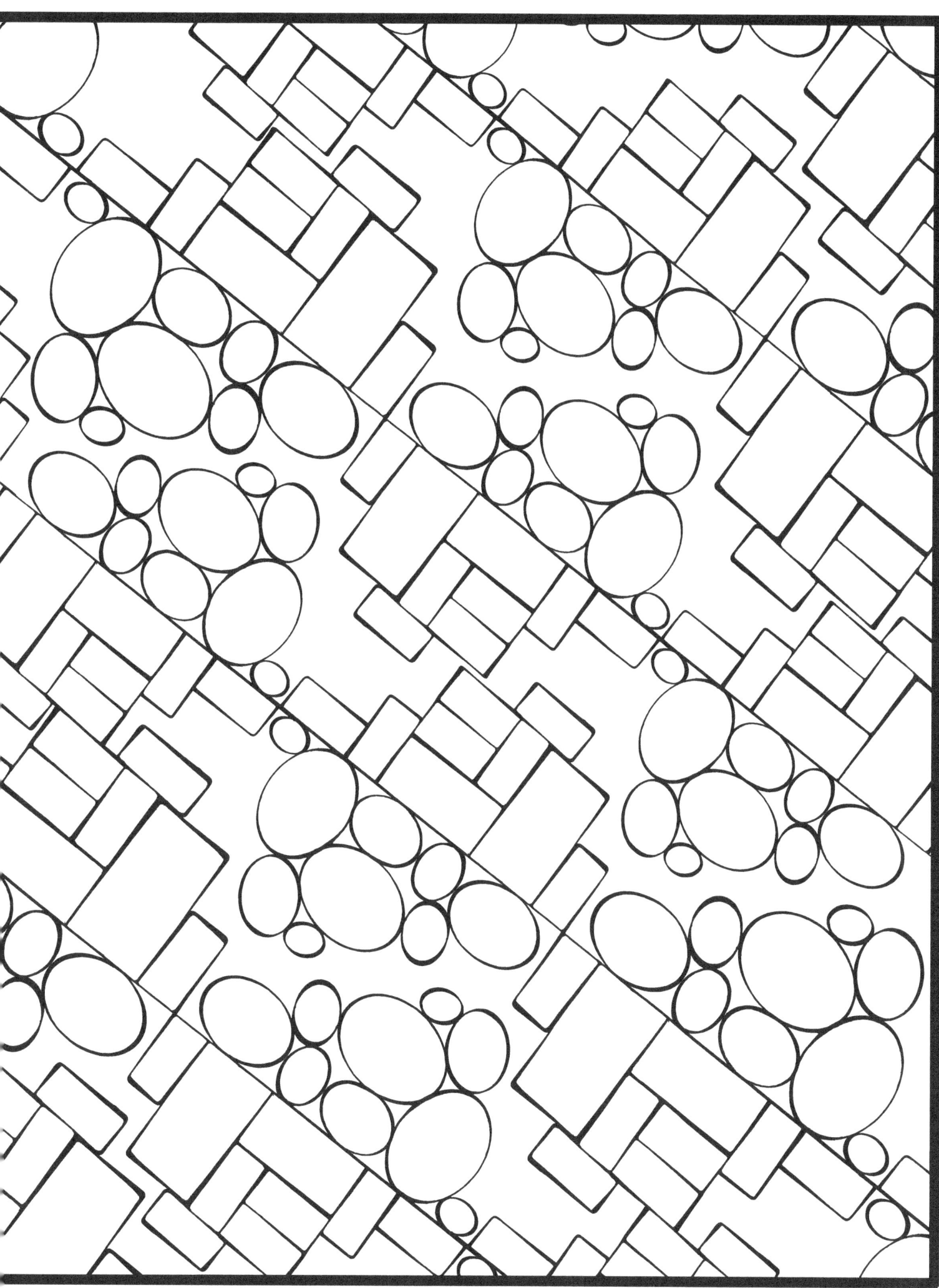

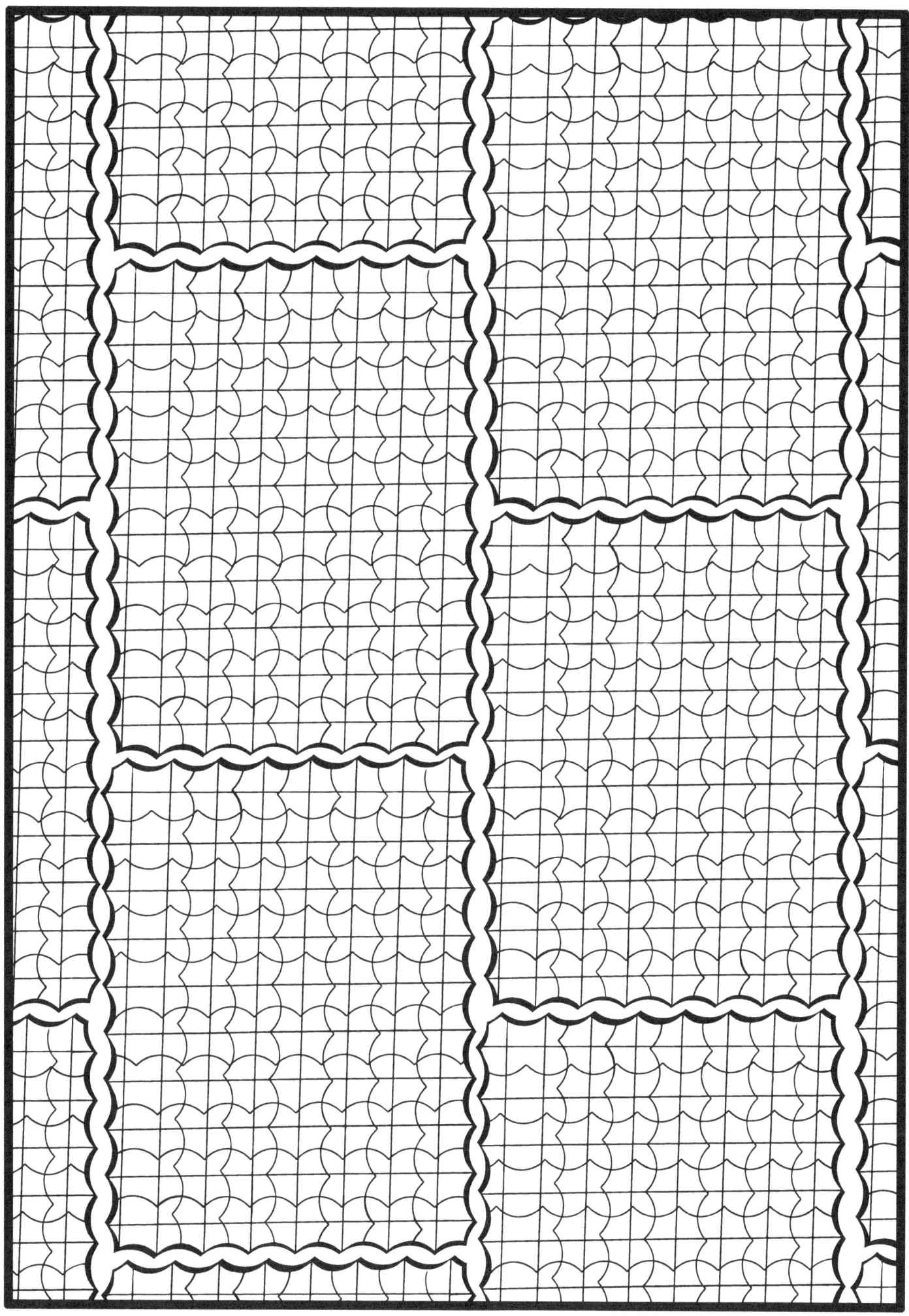

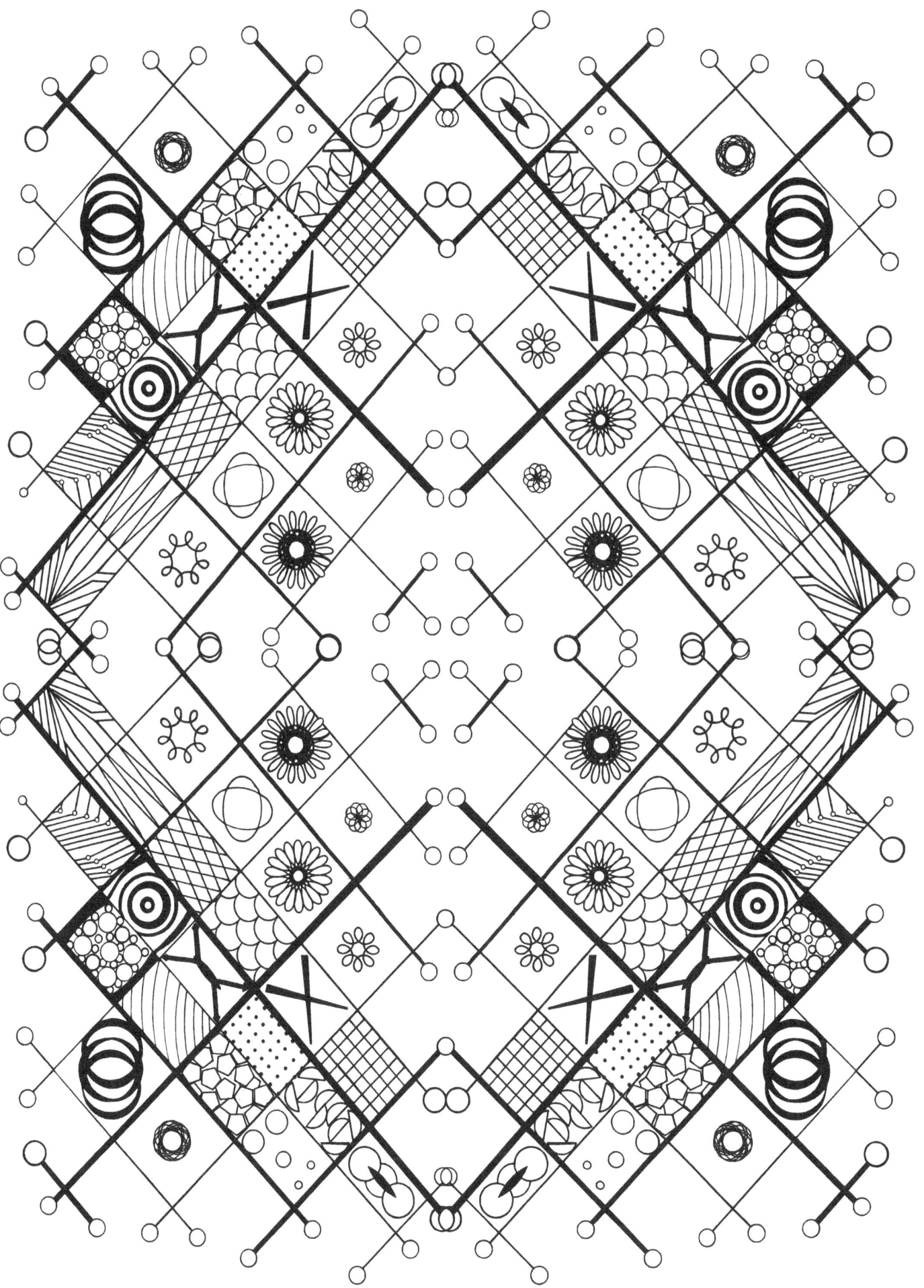

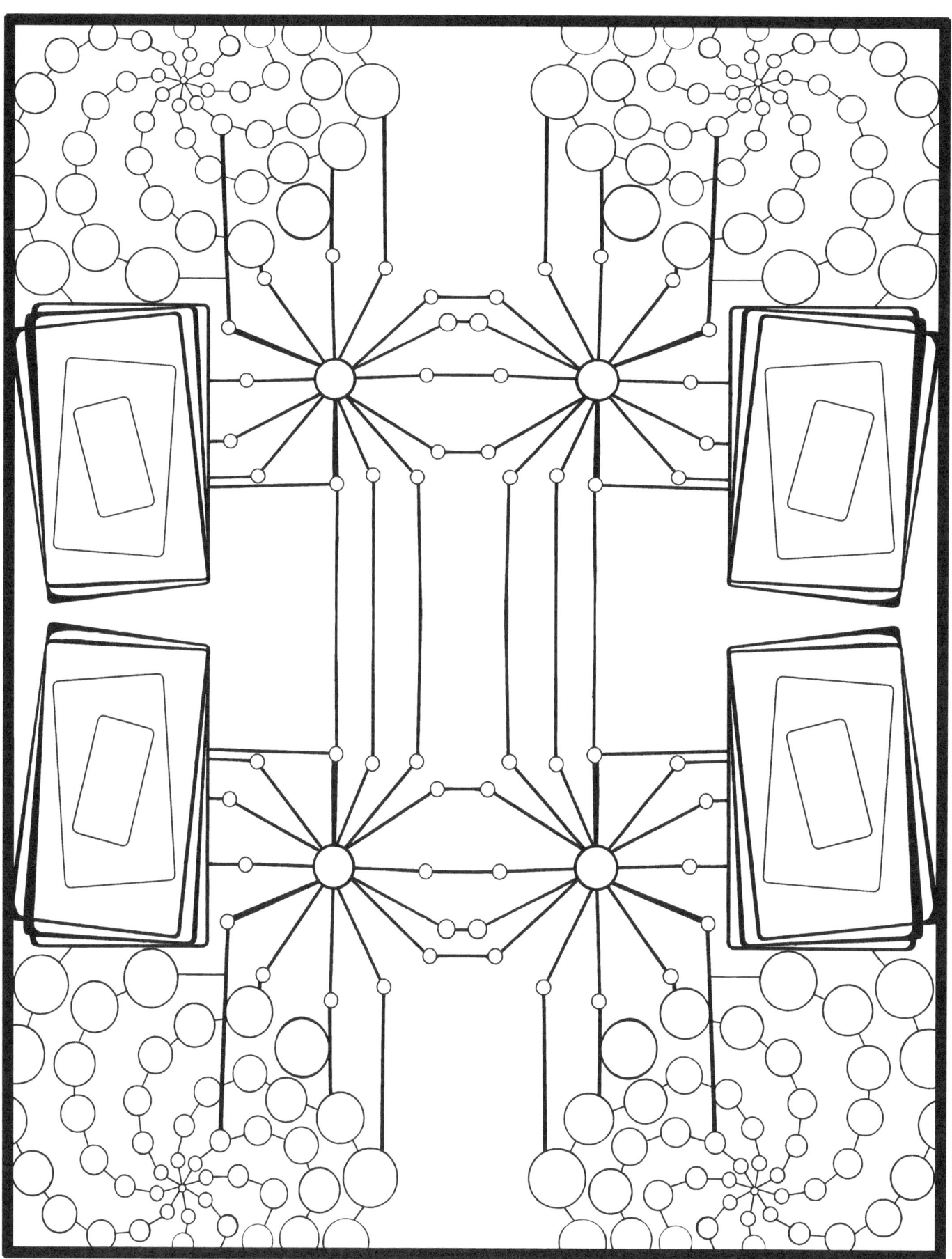

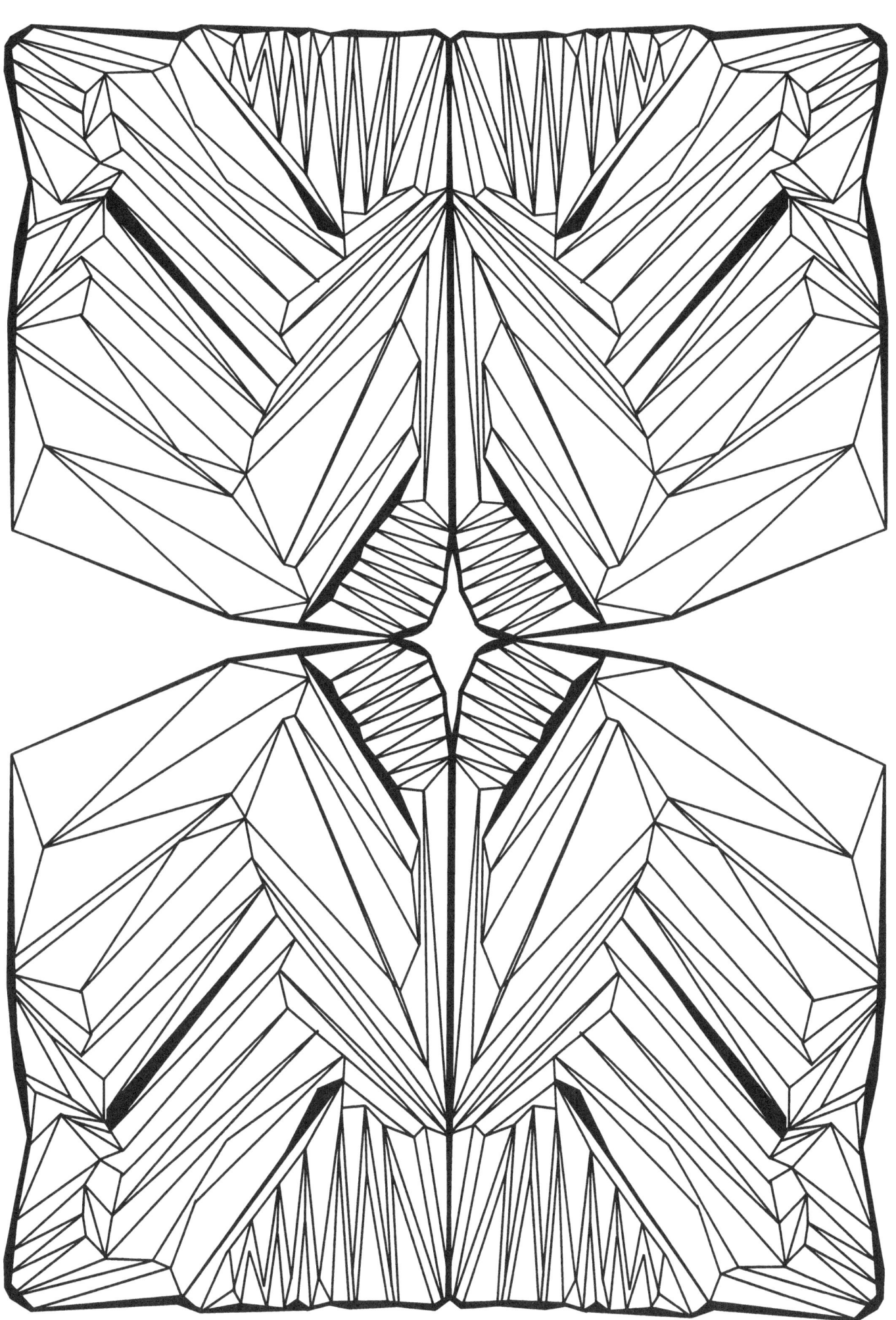

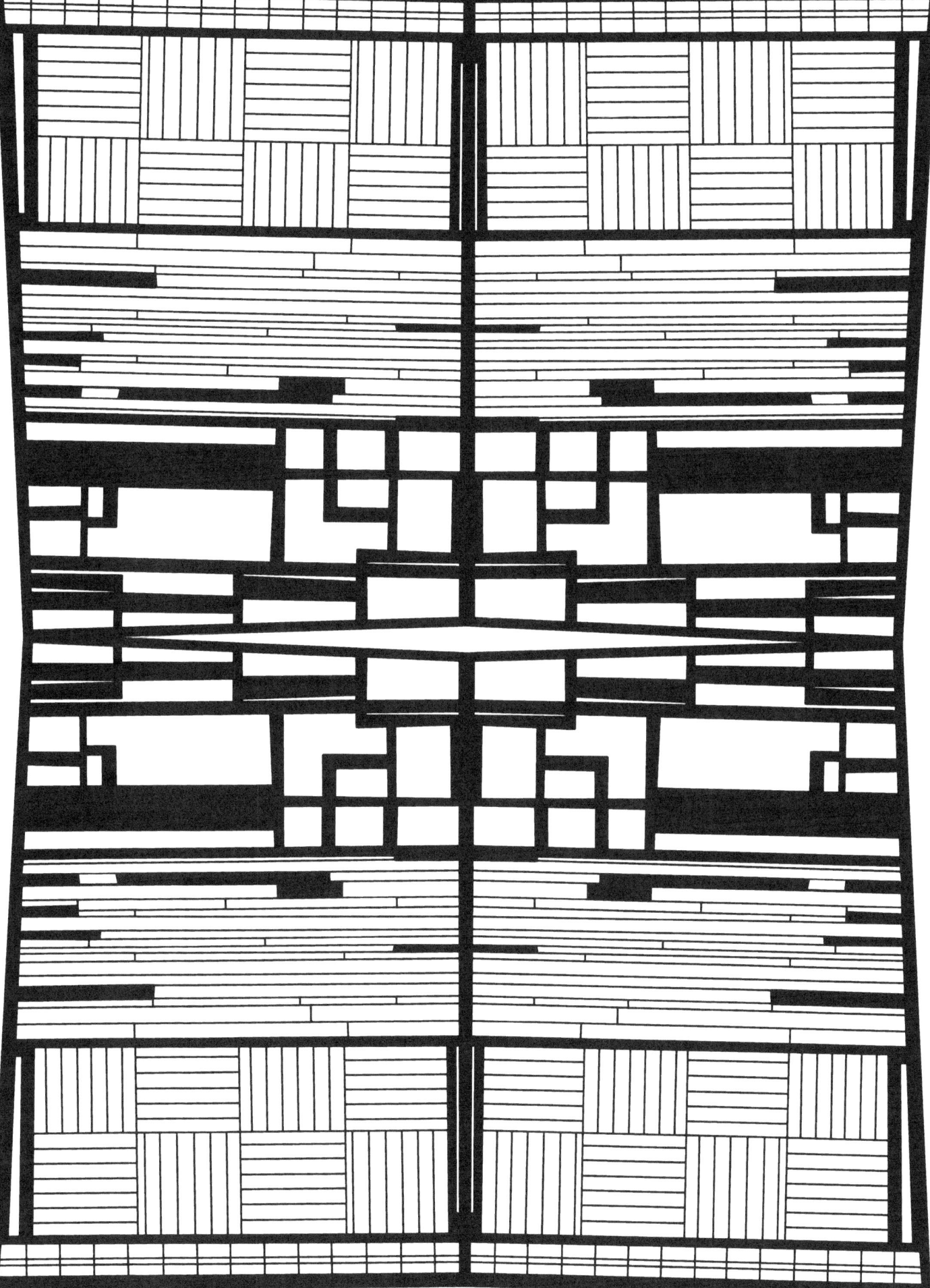

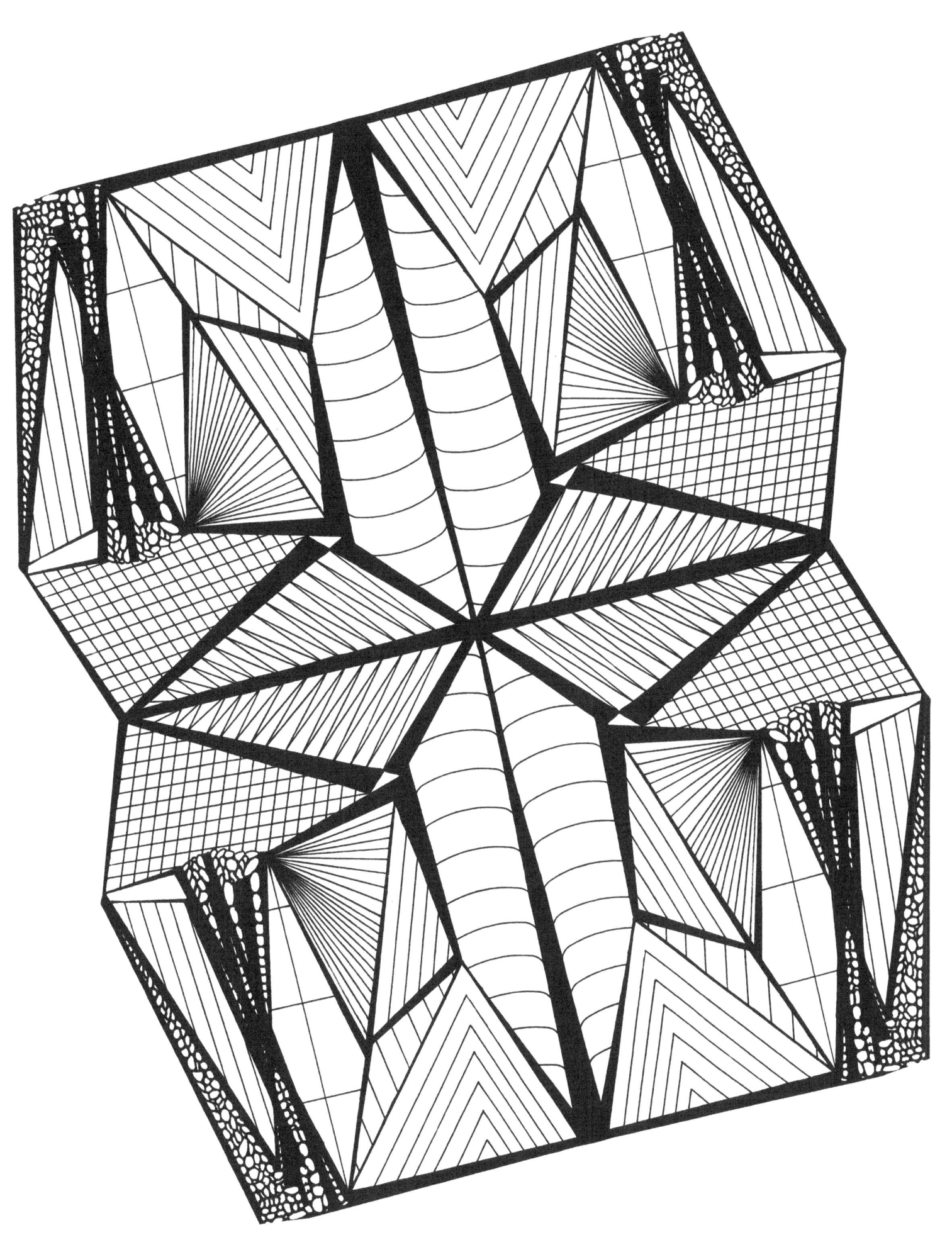

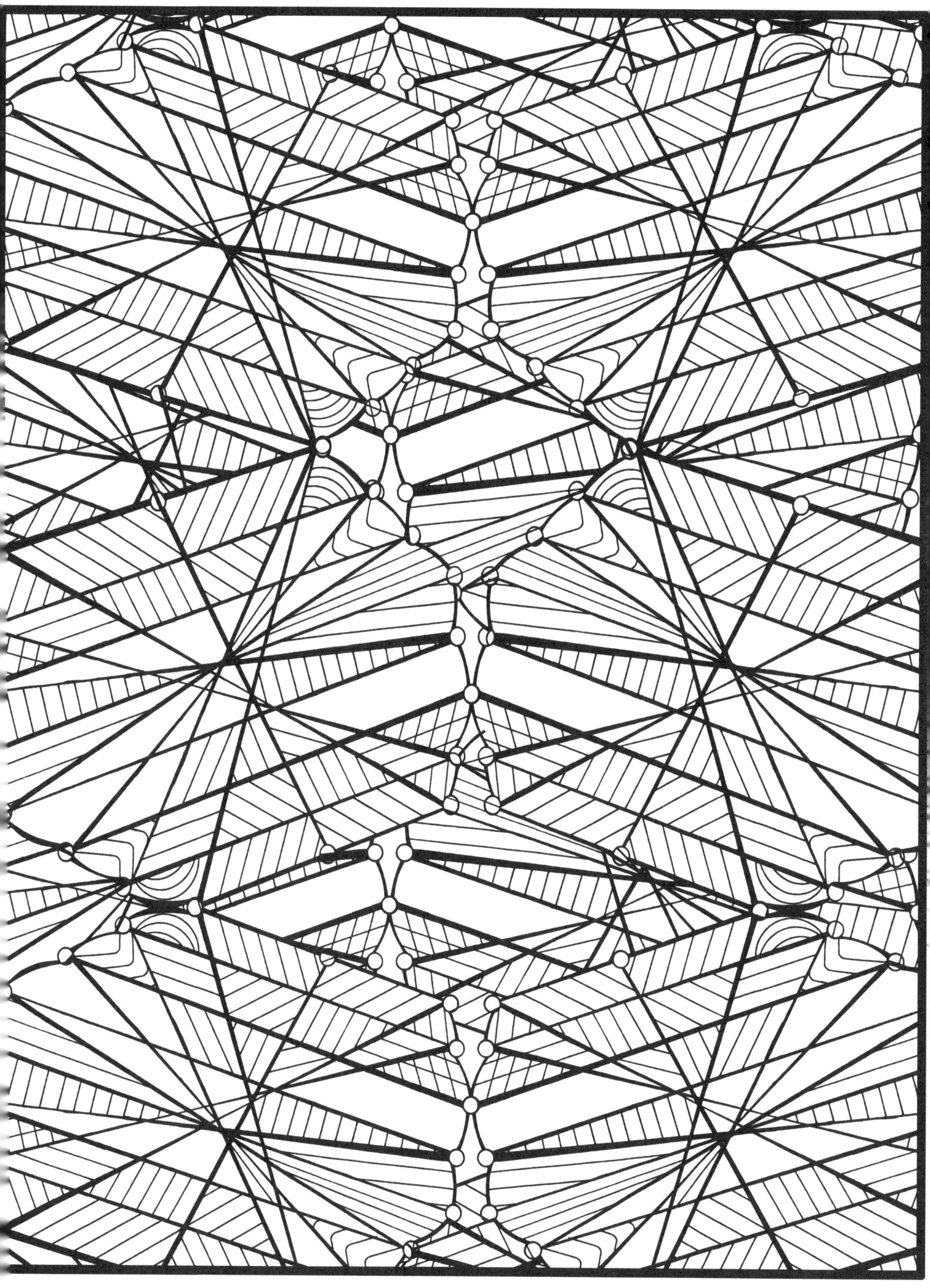

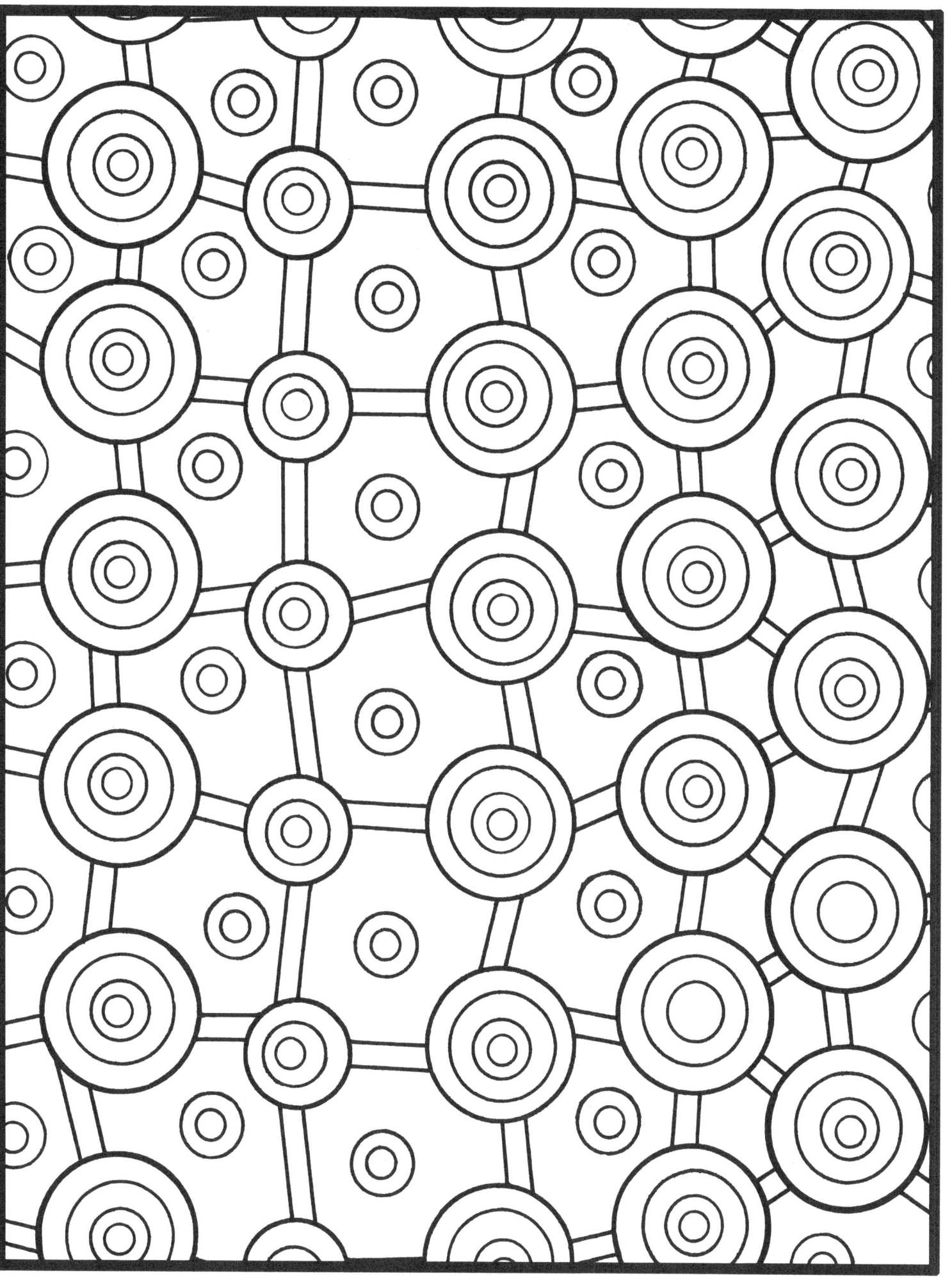

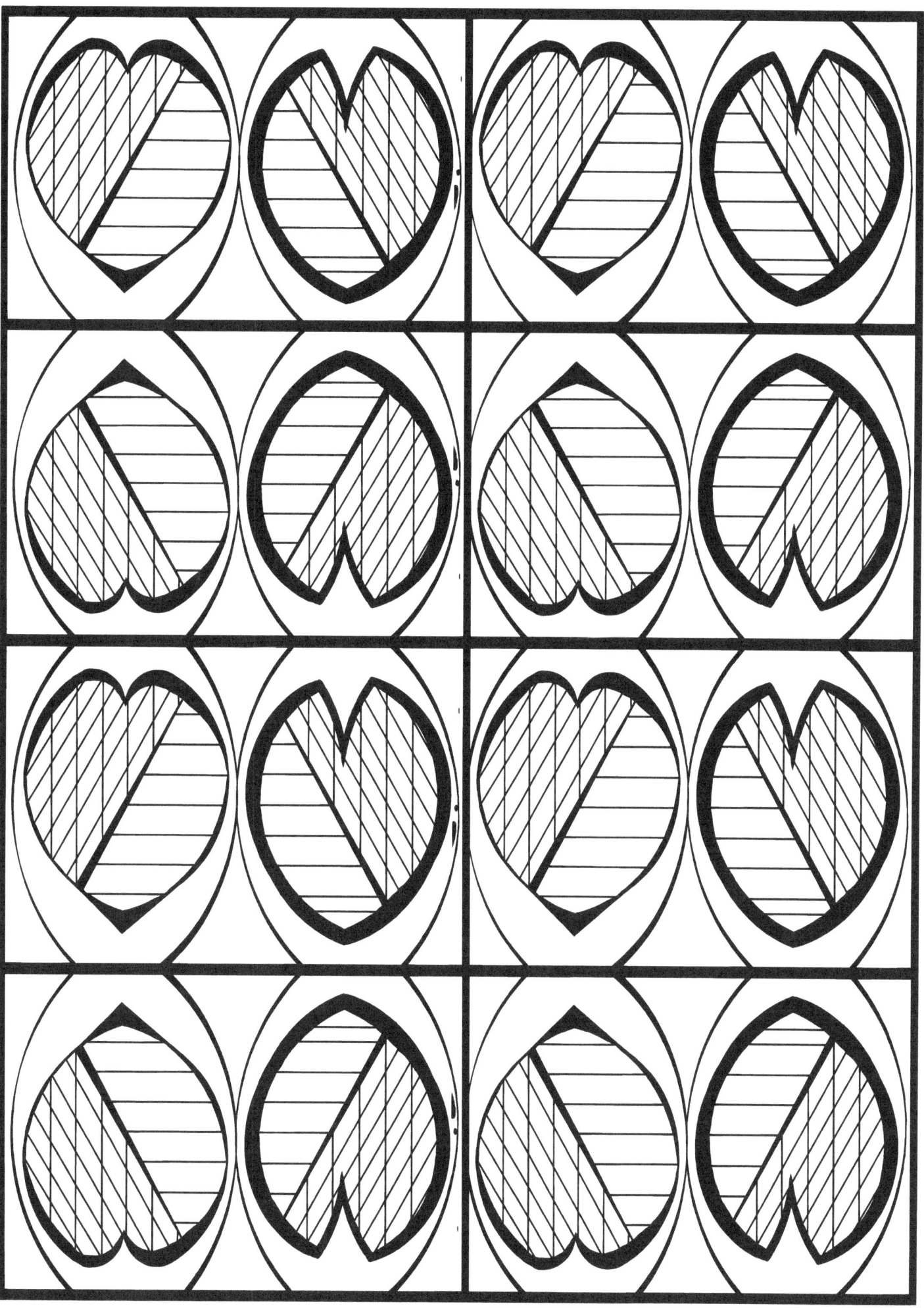

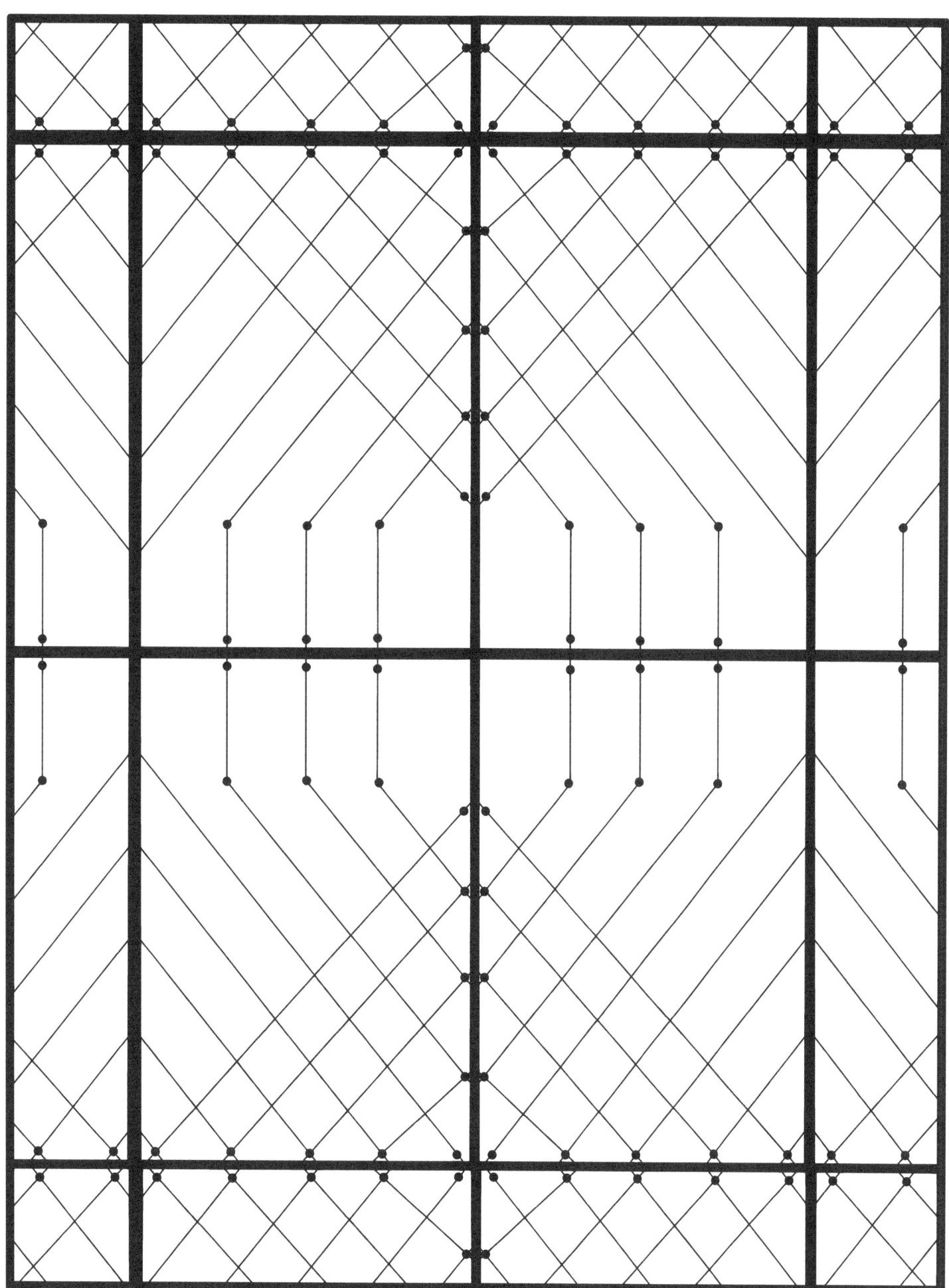

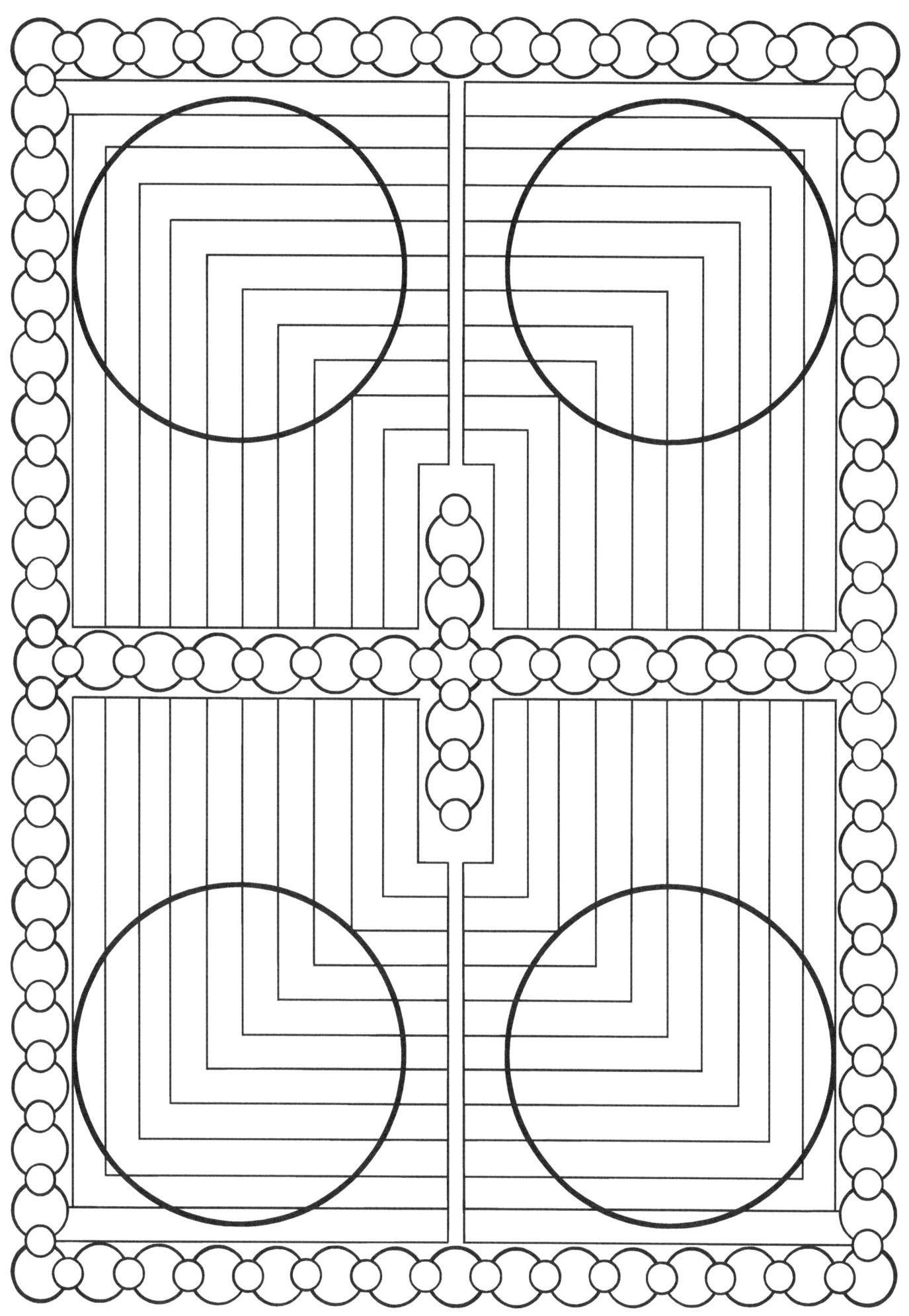

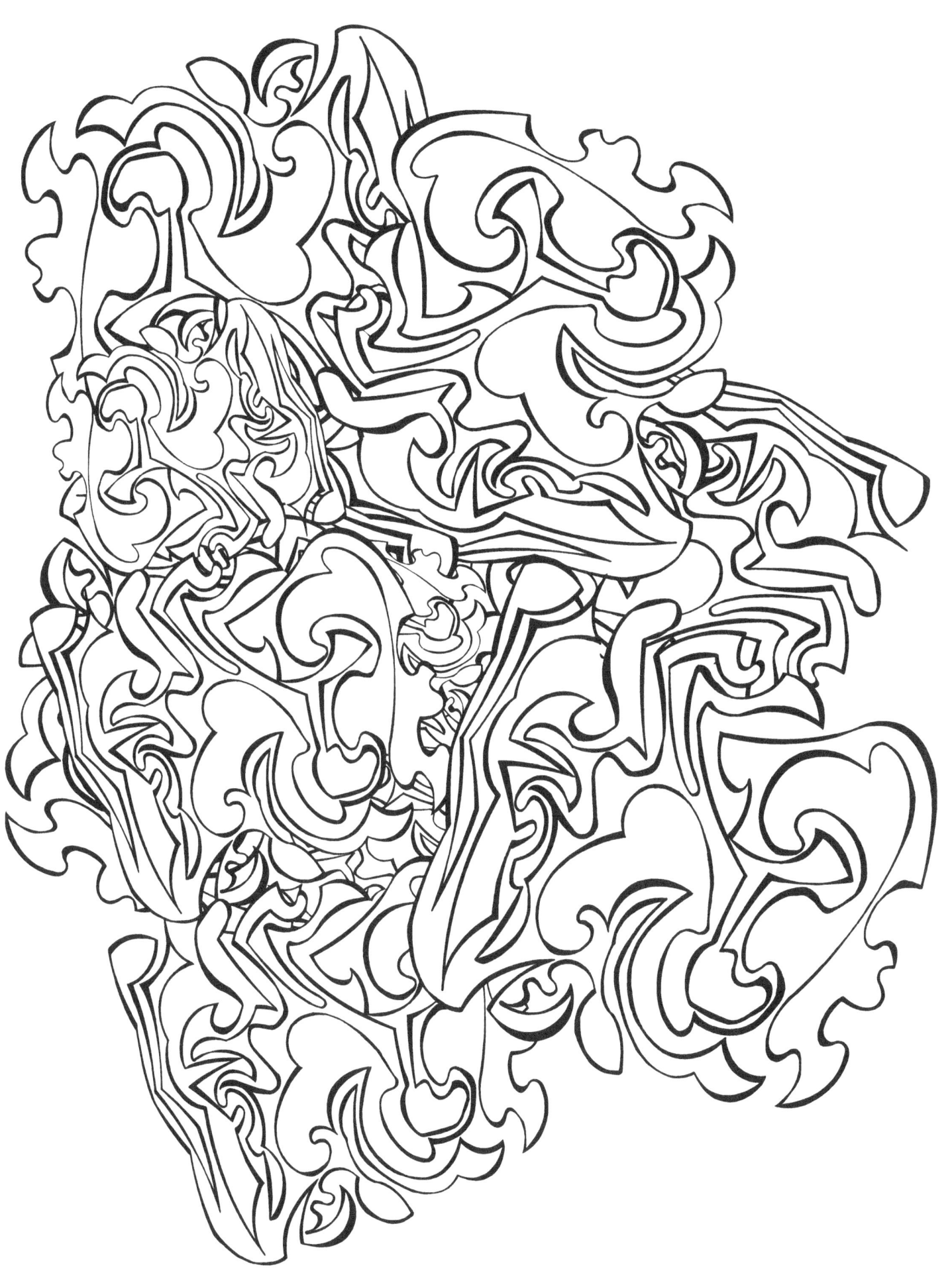

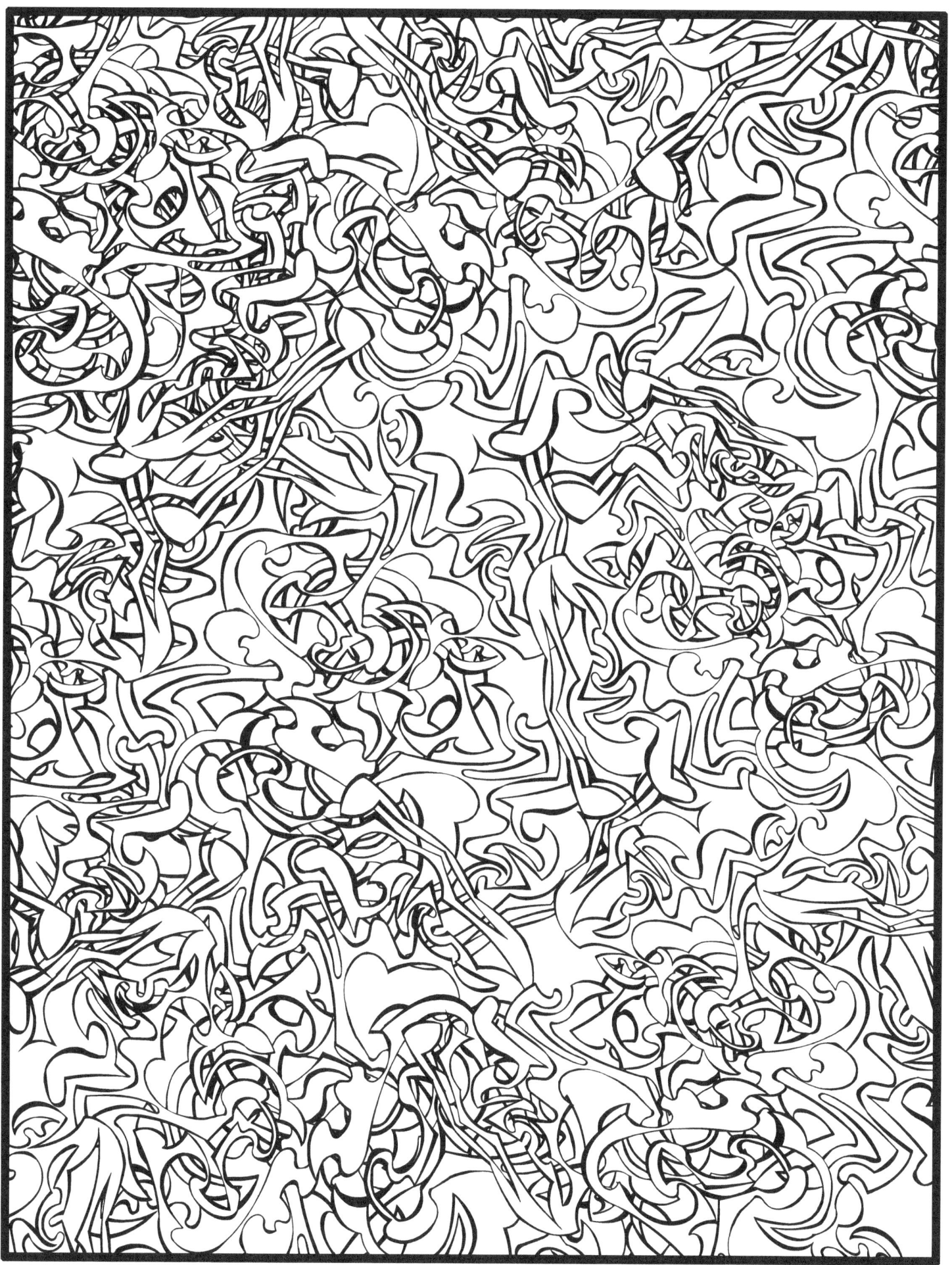

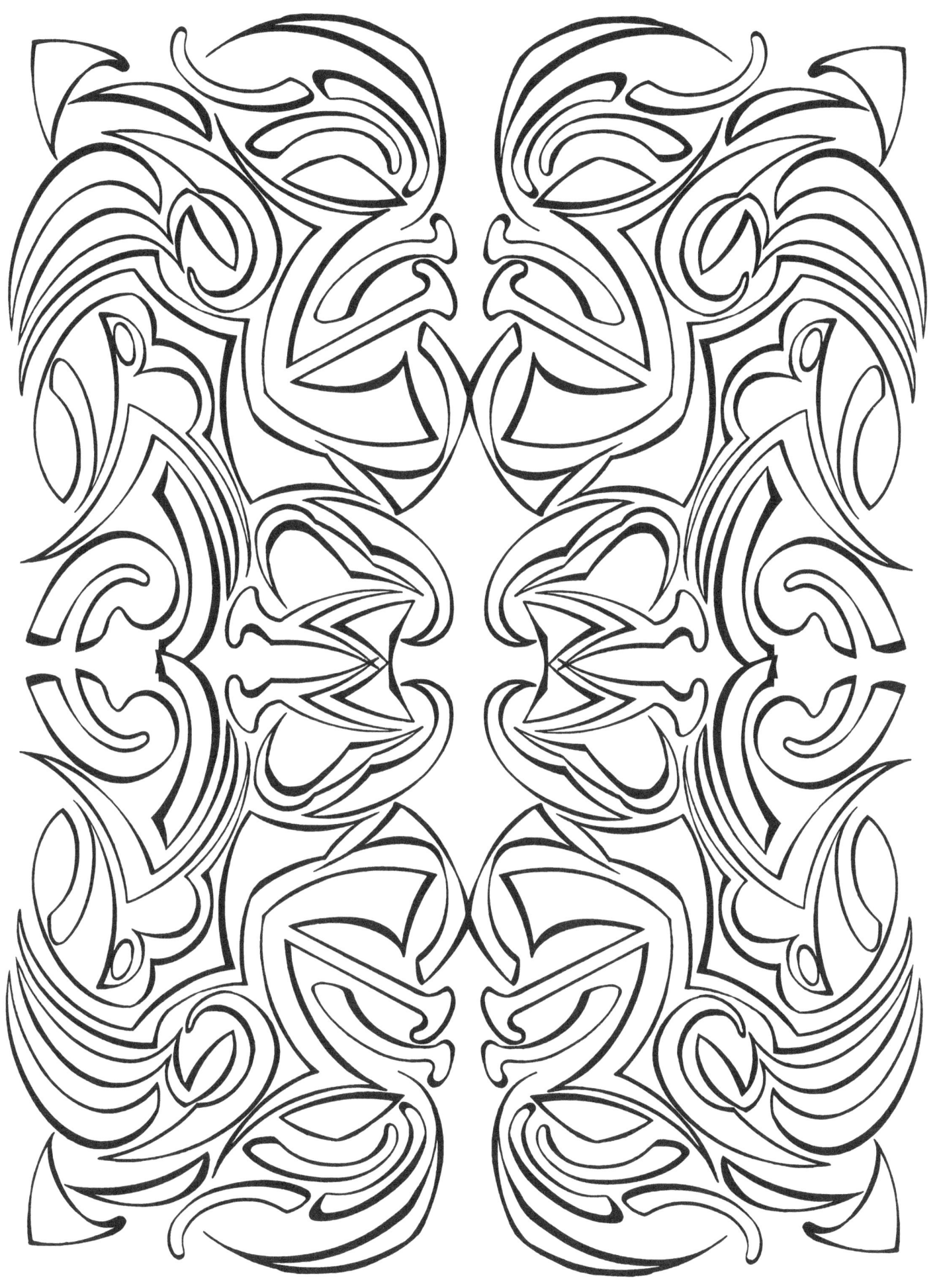

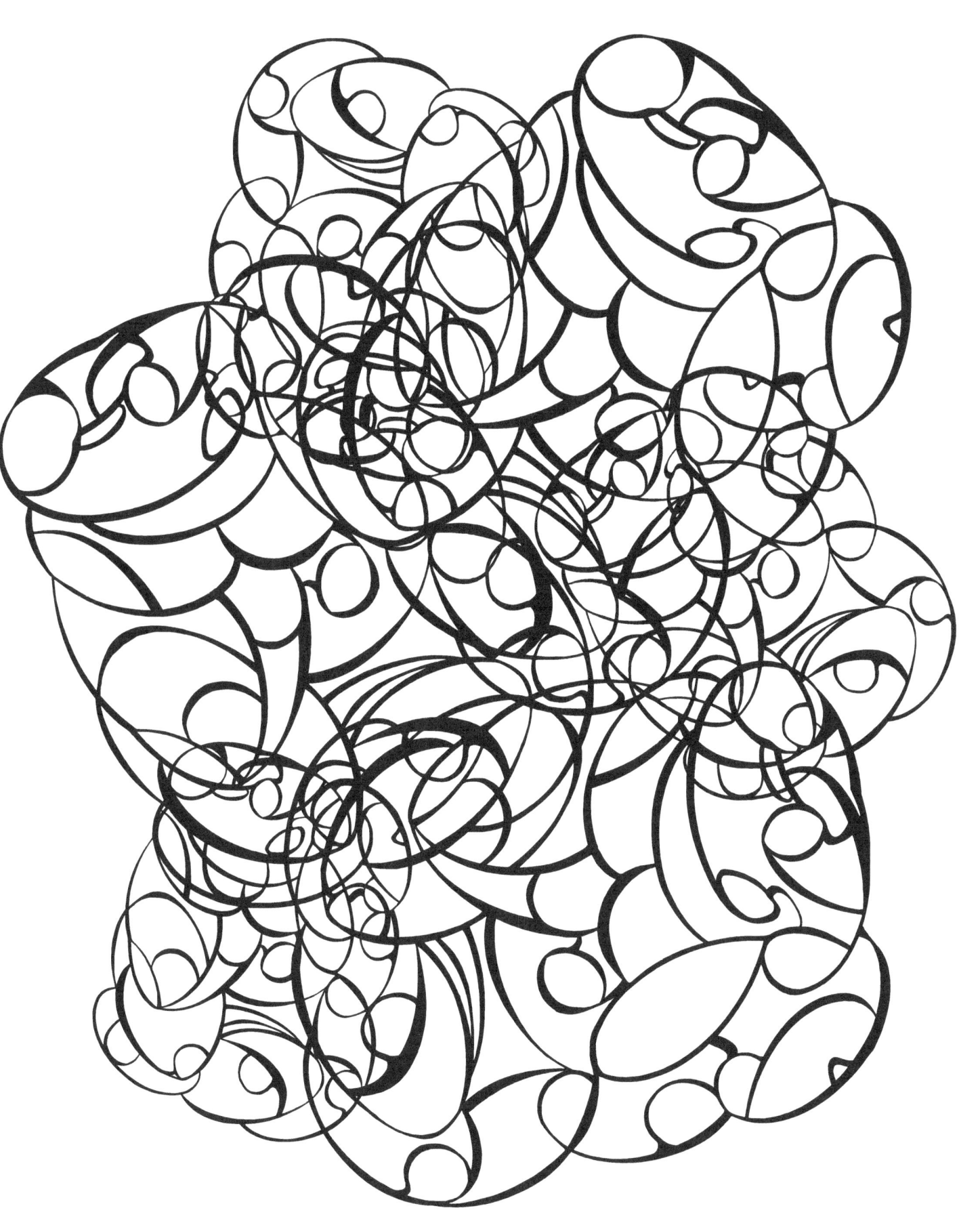

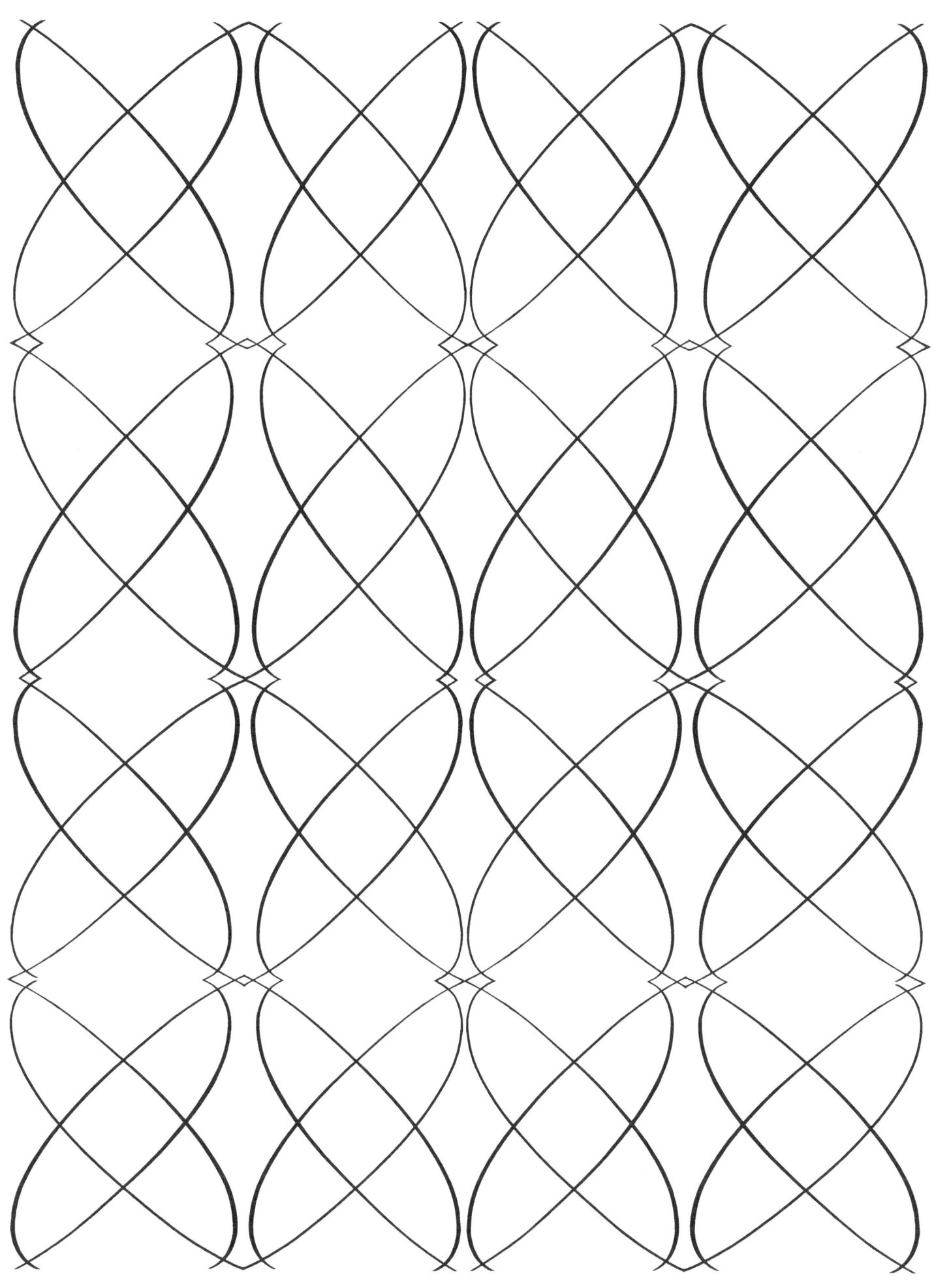

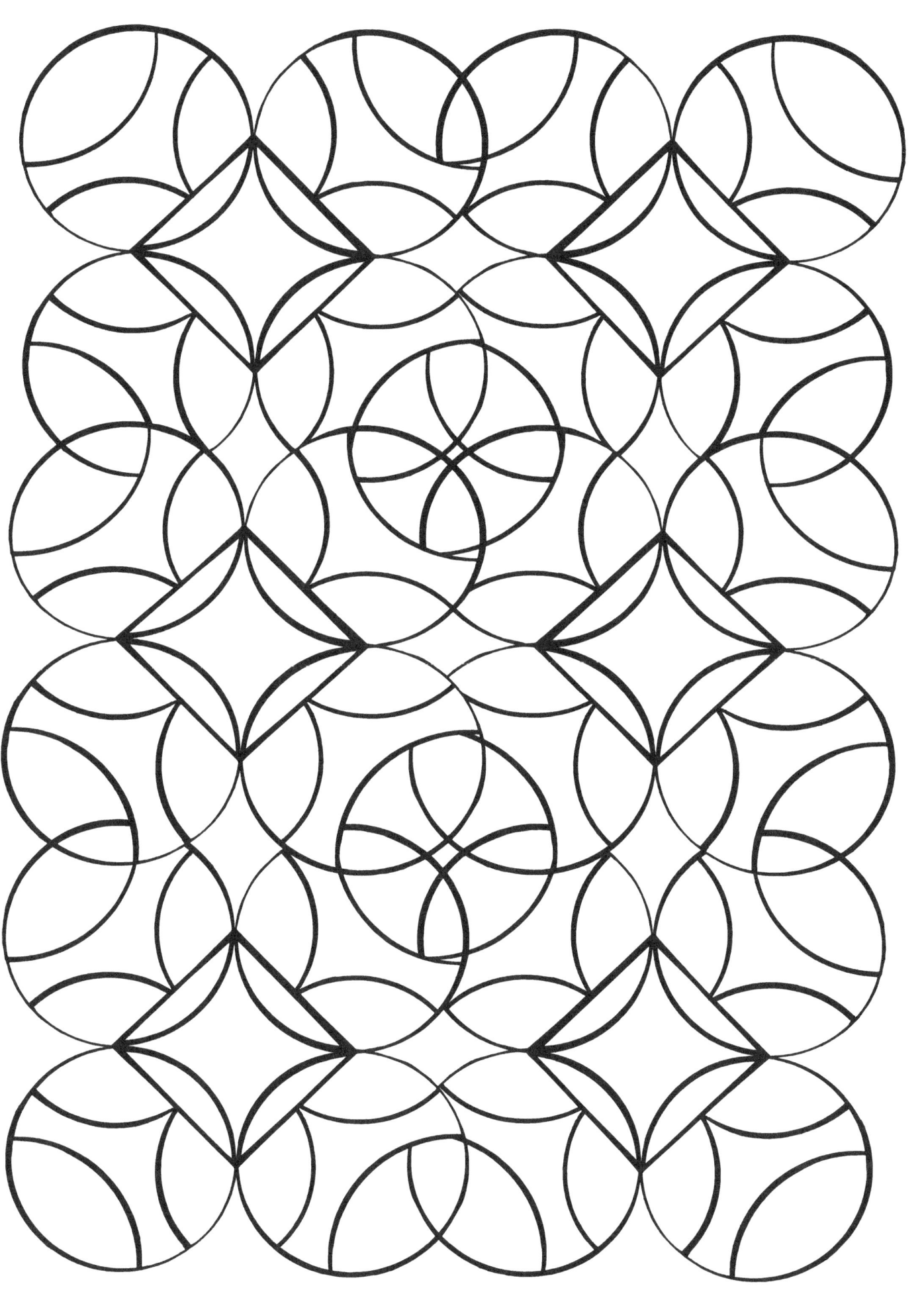

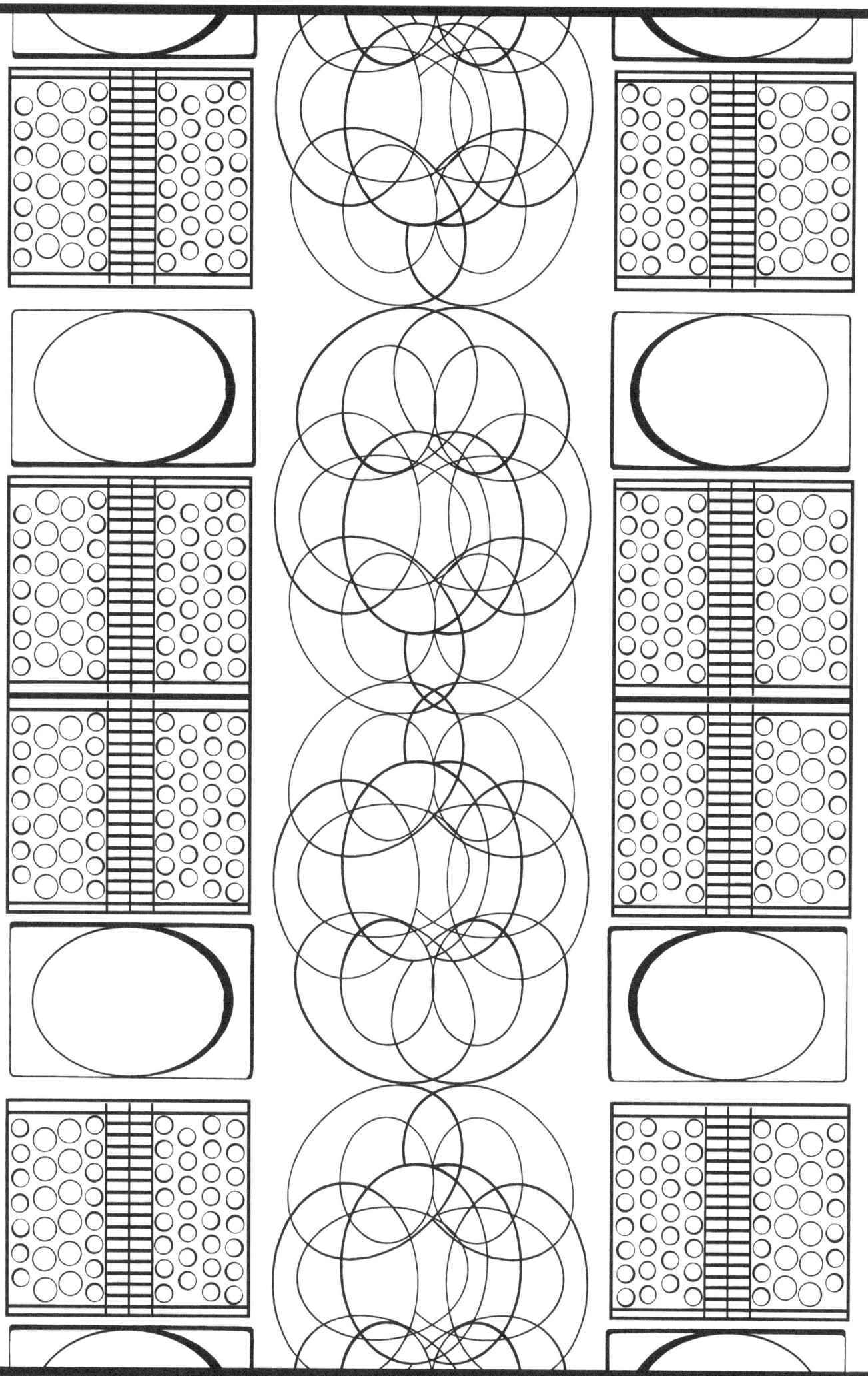

www.ingramcontent.com/pod-product-compliance
Lightning Source LLC
Chambersburg PA
CBHW080710190526
45169CB00006B/2315